D0854900

VERMEER'S
MISTRESS AND MAID

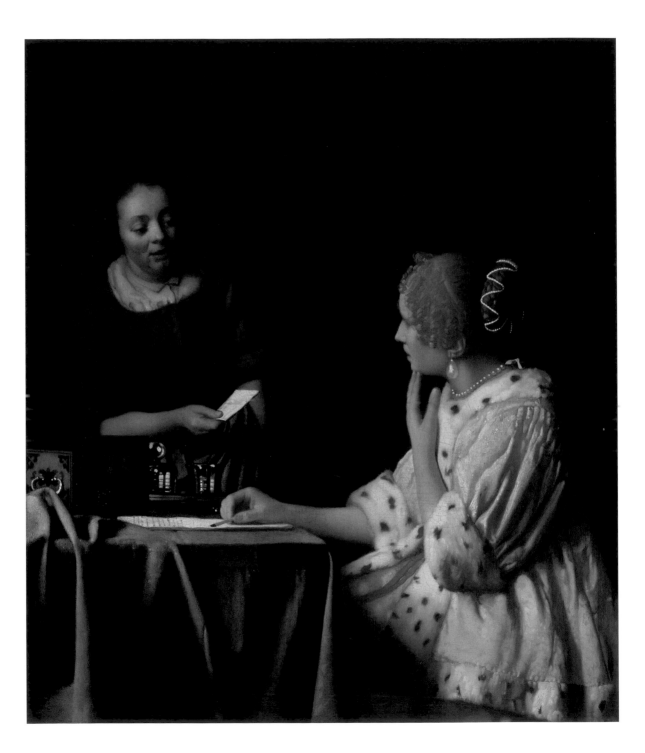

VERMEER'S
MISTRESS AND MAID

Margaret Iacono

James Ivory

The Frick Collection, New York
in association with D Giles Limited, London

g

FRICK DIPTYCH SERIES

Designed to foster critical engagement and interest the specialist and non-specialist alike, each book in this series illuminates a single work in the Frick's rich collection with an essay by a Frick curator paired with a contribution from a contemporary artist or writer.

© 2018 The Frick Collection

"Two Letters on a Day in the Mid-1660s"
© 2018 James Ivory

All rights reserved. No part of the contents of this book may be reproduced, stored in a retrieval system, or transmitted in any form or by any means, electronic, mechanical, photocopying, recording, or otherwise, without the written permission of The Frick Collection.

First published in 2018 by The Frick Collection
1 East 70th Street
New York, NY 10021
www.frick.org

Michaelyn Mitchell, Editor in Chief
Hilary Becker, Associate Editor

In association with GILES
An imprint of D Giles Limited
4 Crescent Stables,
London, SW15 2TN, UK
www.gilesltd.com

Copyedited and proofread by Sarah Kane
Designed by Caroline and Roger Hillier,
The Old Chapel Graphic Design

Typeset in Garamond
Produced by GILES
Printed and bound in China

Hardcover ISBN: 978-1-911282-37-2

Library of Congress Cataloging-in-Publication Data

Names: Iacono, Margaret, author. | Ivory, James, author. | Frick Collection, issuing body.
Title: Vermeer's Mistress and maid / Margaret Iacono, James Ivory.
Other titles: Frick diptych series.
Description: New York : The Frick Collection ; London : in association with D Giles Limited, 2018. |
Series: Frick diptych series | Includes bibliographical references and index.
Identifiers: LCCN 2018018859 | ISBN 9781911282372
Subjects: LCSH: Vermeer, Johannes, 1632-1675. Mistress and maid. | Frick Collection.
Classification: LCC ND653.V5 A77 2018 | DDC 759.9492--dc23 LC record available at https://lccn.loc.gov/2018018859

Distributed in the USA and Canada by
Consortium Book Sales & Distribution
The Keg House
34 Thirteenth Avenue, NE, Suite 101
Minneapolis, MN 55413-1007
USA
www.cbsd.com

Front cover and pages 58 and 62: Johannes Vermeer, *Mistress and Maid*, 1666–68 (details of frontispiece)
Frontispiece: Johannes Vermeer, *Mistress and Maid*, 1666–68

CONTENTS

DIRECTOR'S FOREWORD

It is a great pleasure to publish this second title in the Frick Diptych series, each volume of which presents a focused look at an important work in the collection with an essay by an art historian and a contribution by a contemporary writer or artist. The masterpiece *Mistress and Maid*, the third Vermeer purchased by Henry Clay Frick, has a beauty and a charged tension that make it one of the most beloved works in the collection. Margaret Iacono, Associate Research Curator, places the painting in historical context, discusses the mystery of the moment depicted, and reveals the preliminary results from a recent technical study. An inventive vignette by the legendary filmmaker James Ivory imagines the story behind the painting and beautifully complements Margaret's essay. Our deep appreciation goes to both authors for the wonderful book they have created.

At the Frick, thanks are due to Xavier F. Salomon, Peter Jay Sharp Chief Curator; and Alexis Light, Senior Manager of Media Relations and Marketing; as well as to Editor in Chief Michaelyn Mitchell, who managed the production of the publication and, with Associate Editor Hilary Becker and editorial volunteer Serena Rattazzi, edited the texts. We would also like to acknowledge our publishing partner, D Giles Ltd.

Ian Wardropper
Director, The Frick Collection

ACKNOWLEDGMENTS

I am deeply obliged to the following colleagues who generously aided me with this essay through their review of early versions and their thoughtful discussions with me about Vermeer's *Mistress and Maid*: at the Metropolitan Museum of Art, Maryan Ainsworth, Curator of Northern Renaissance Painting, and Elizabeth Cleland, Associate Curator of European Sculpture and Decorative Arts; at the National Gallery of Art, Washington, Arthur K. Wheelock, Jr., Curator of Northern Baroque Paintings; at the Frick's Center for the History of Collecting, Esmée Quodbach, Assistant Director, Programs, and Editor in Chief; and independent art historian Yvette Bruijnen, who is also an editor of *Oud Holland*. I want to particularly acknowledge Xavier F. Salomon, Peter Jay Sharp Chief Curator at the Frick, for his invaluable counsel.

Other Frick colleagues who deserve my thanks are Michaelyn Mitchell and Hilary Becker, for their organization of the project and meticulous editing of this text, and archivists Sally Brazil, Susan Chore, and Julie Ludwig, for their kind help with materials relating to Henry Clay Frick's purchase of the canvas. I also wish to recognize former curatorial interns Jennifer Haller, Isabel Dicker, Hannah Augst, and Phoebe Boosalis for their assistance.

At the Metropolitan Museum of Art, I am especially grateful to Conservator Dorothy Mahon and Research Scientist Silvia A. Centeno for undertaking the technical studies that have resulted in many new discoveries about the painting. Many thanks also to Evan Read, Associate Manager for Technical Documentation, Paintings Conservation, who did the photography, as well as the IRR capture. Finally, in the spirit of the love letter, a prominent theme in this book, I dedicate my essay to Bill Wertz for his unflagging support and enthusiasm for this and all of my endeavors.

Margaret Iacono
Associate Research Curator

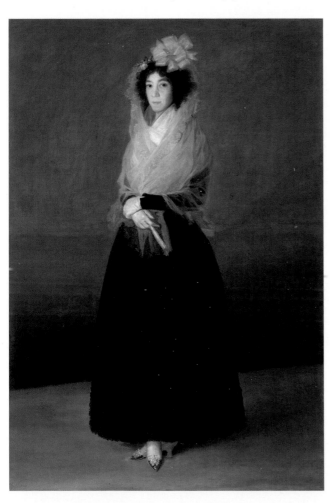

I GREW UP IN A SMALL WESTERN TOWN and was never in any kind of picture gallery before I was ten. The Old Masters were represented in our house by a small framed sepia-toned reproduction of Franz Hals's "Laughing Cavalier." The nearest picture gallery was four hundred miles away, in San Francisco, a city we visited annually to celebrate my mother's birthday. My main memory of the large art museum in Golden Gate Park is not of the many pictures on the walls but rather of me—the future film director—running up the steps to one of the thrones said to have been owned by Napoleon Bonaparte and perching on it for a moment when the guard's back was turned. Later, studying architecture in college, I took my share of art history courses and in time drew up a list of my favorite painters: El Greco, Goya, Chardin, and Vermeer. I later added Matisse. My enthusiasm for these masters was gained mostly from illustrations in books. But I did see a superb St. John the Baptist by El Greco in San Francisco's Palace of the Legion of Honor, and perhaps it was this picture that led to my making a list of favorite painters. Soon after, on my first visit to the Louvre, I stood enchanted in front of Francisco Goya's composed but sadly plain Marquesa de la Solana, all dressed up for her artist and creating a formidable presence. To this day, she suggests to me the basic condition of all advanced human society more than any other painted portrait I've ever seen. I don't remember my emotions on encountering my first Vermeer, "The Astronomer," also at the Louvre. Perhaps I passed it by, hoping to see some young pearl-bedecked girl caught in the light from a big window like the astronomer's. At that time, I had never been to New York. It would be years before I visited the Frick or the Metropolitan, before I encountered the Frick's "Mistress and Maid," a painting in which the proverbial calm and still surfaces of Vermeer's art are ruffled by one of the deepest and most universal of human emotions: the psychological tension contained within the gesture of a proffered, sealed letter.

TWO LETTERS ON A DAY IN THE MID-1660s

James Ivory

One letter announces that Ludolph is coming to see Cornelia—that he is on his way and will soon be there. He gives his reasons for being late. She wishes he were not coming at all. Cornelia could send a reply that she is unwell, but that would be a lie. It would also be a lie to say, when he does come, that she is glad to see him. She would much prefer to see Adriaen, but her father disapproves of him. Adriaen makes her laugh. He once put all of her fingers into his mouth, first kissing the tips of each as if she were a child. It made her feel faint with laughter. And something new—something that made her feel out of breath. Then, one by one, Adriaen offered his own slim fingers, which had been dipped into shaved ginger. She had to sit down afterward, it so stirred her. Cornelia could not imagine putting Ludolph's blunt, red fingers, with their many gold rings, into her mouth.

Ludolph plans to sail to Nieuw Amsterdam on one of his ships. Will he walk in the snow and ice in that terrible place, she wondered, in those silk shoes of his with the pretty little bows and colored heels and toes, made for dancing? The red men will shoot arrows at him and make him look a ridiculous figure when he tries to run away. Standing in the snow in his big boots, Adriaen would talk peacefully to the red men. Not bartering with trinkets but telling them about the boyhood of Jesus and how he astonished the high priests in the temple.

"I *will* tell Ludolph a lie," Cornelia thinks. She takes paper out of a drawer to write a letter to Ludolph, thinking carefully about what she can tell him to make him stay away. Her maid, Amalia, stands ready to take her mistress's letter. She does not like Ludolph either. One day, when she carried a letter

from him announcing a visit, Cornelia read it aloud, and Amalia said "Ha!" sharply, turning her face away, and began to adjust the curtains behind her chair. She knows Cornelia's feelings for Adriaen. Once, as he was leaving the house, Amalia saw him take off his big black hat and put it on Cornelia's head, then pull open the heavy door for her so that snow blew in. He pretended to push her out and take her with him, but Cornelia tore off his hat and pulled it down over his head so that only his chin and beard stuck out. His beard was already full-grown for such a young man. His mother hated it, he told Cornelia, and wept when she saw him like that. Cornelia allowed herself to brush it with her hand in defiance of his mother. She had never touched a man's chin, not even her father's. Adriaen's whiskers felt wiry and strong. She told Amalia to touch them too, which she did, more hesitantly. When the door at last closed, the laughing girls heard his boots on the steps: bang, bang, bang. Cornelia's face felt as if it were on fire. She wished she had some of the snow to cool it off. Later, they found an old cushion that had been stuffed with animal hair and was spilling its guts. They pulled some out to see what a man's beard would feel like under their own chins.

Her father once unkindly told her, "Adriaen Gansvoort only comes to see you because you are an heiress." He said it was unseemly for her and Adriaen to still play their childish games, that as his only daughter she must never forget

her position. Adriaen's family is obscure, her father said. He had made inquiries in Delft and even Amsterdam. Cornelia knew she would never be allowed to marry Adriaen. Her father had decided on Ludolph, whose many virtues he kept enumerating until she wanted to shout, "Stop!" Ludolph's principal virtue was that he was very rich. Another was that he was devout, and a third was that he cared so well for his elderly mother, Petronella van Everdingen.

Cornelia remembers: Ludolph once asked my father if I might be shown to his mother, and I went, though not at all wanting to. His mother was wearing a stiff, old-fashioned pleated ruff that looked like a big white plate, her head placed in the middle of it like a piece of shriveled fruit or a stewed apple with little eyes. Ludolph told me before going in that I should take her hand, but when I entered her room I took a step backward instead of forward. Mother and son both frowned. As Ludolph led me up to her, his mother said, without first greeting me, "Ermine should only be worn by royalty!" Then she said, "Are those pearl earrings or glass drops made in Venice to look like pearls? Only

royalty can afford pearls of that size." I put my hands up as if to hide my ears, and she settled back, her head wobbling on its plate. I was caught off guard, but I defended myself to this wild old woman and blurted out that the ermine on my yellow mantle was imitation and that the black spots had been painted on the white fur, which is often done. This made things worse. She shouted "Imitation!" and raised her hand as if to silence or even strike me. Ludolph led me away then, pulling me by the arm, and said, "My dear mother is not well today." As he led me down the stairs, he said, "Have you never heard of the sumptuary laws?" In his anger, he held my hand so tightly that his many gold rings bit into my fingers. As we went down, I was thinking of my father's old mother, who, at a certain time, had been put into a big cradle that a servant rocked with a foot while she knit, and life went on around her. Soon, Ludolph would be forced to put Petronella van Everdingen into her own cradle—a very grand gold one to be sure—where she would lie and shout things about pearls and ermine fur. But I would never see or hear her, I swore.

As I was getting ready for bed that night, after I said my prayers and as Amalia was holding back the coverlet for me, I committed another sin. I thought to myself, "Perhaps Ludolph will be lost at sea on his way to Nieuw Amsterdam." And this wicked thought made me slap my hand over my mouth so that Amalia thought that I had taken ill. She stood by the side of the bed, petrified, still holding up the coverlet for me to get under. But my mood had changed. I realized I was now smiling. I was thinking that, whatever happens, Ludolph will be gone for a very long time on his trip.

Once, at Ludolph's, when Cornelia's father forced her to make a visit, the water in the canal had rapidly risen and flooded his lower floor so that he had taken off his shoes and elegant hose. She saw his bare feet and quickly looked away. He had crooked toes that didn't look clean, and dirty nails. He had rolled his silk breeches well above his white knees and was shouting orders. Boxes and chairs floated in the water. He seemed more interested in saving his valuable swimming chairs and caskets than in saving her, Cornelia had said afterward. Instead, Ludolph ordered his Batavian servant to carry her to safety. The servant, who was immensely tall and strong—a giant named Untung— picked Cornelia up in his arms and carried her out. He had a strange smell, she told Amalia. Not a bad smell, not a porter's smell. It was something like

the smell of her father's counting house and its spices. As Untung went out with Cornelia in his arms, her head rested against his open shirt and bare chest. She also told Amalia that his skin, though brown, was as smooth as silk. He took her to her father's boat and very carefully placed her in it, like a precious burden that must be delivered safely, one that had come all the way from Batavia. He set her down on a wooden case stamped with black letters, "Arcelli Fontana Castello di Monteventano."

The other letter was from Adriaen. Cornelia could see his handwriting on it, and she snatched it away rather too quickly from Amalia's hand. She opened it after Amalia, who was closing the heavy curtain to shut out the cold drafts, had left. Adriaen was delayed but implored her to let him come the next day.

Impatiently, Cornelia rang her little bell, and Amalia reappeared. Had he given any reason as to why he was so delayed? Had he sent no token with his letter? Often he enclosed a blue and white China bead. It was his way of telling her he thought often of her, rolling the bead between his fingers like a devout papist with his rosary. And she would send it back, after enclosing it in the palm of her glove for a day or two, happy in the same thoughts, which her father would never know. Adriaen told her he had once dropped their bead and it had rolled away, down the steps from her house, and almost fallen into the canal. But he had caught it in time. He put a stout thread through the bead and fixed it inside his breeches, where he felt it against him whenever he walked, and where it could never fall out.

Holding Adriaen's letter against her cheek, Cornelia thought: I am too young to marry. I am little better than a school girl, still being taught to write well, to hold the pen in a certain way so that my letters to Adriaen (and yes, to Ludolph too) look elegant and not blotched with ink. I am always aware of Amalia watching me form words she cannot read.

———

Amalia's thoughts: One day, as I was taking Ludolph to my mistress through the narrow corridor, when no one else was about, he grasped me and pushed me into a corner under the stairs, putting his hands inside my dress. I heard my mistress calling me and ringing her bell. We were near a closet so I pulled him into it, and he had his way with me. He was quick and clumsy, and when he tried to force his mouth on mine, I took tight hold of his beard and pushed his face away. He stained my skirt. Luckily, I had no child by him.

In time, I married a man named Seminole Afrikanners. He had once been a slave to a kind master called Cohen, who set him free. My husband is a skilled carpenter and built me a *kas* for our house. But he no longer cares to do that kind of work. He has a fine voice and likes to go to church to sing psalms with our congregation. I stayed on in my mistress's house until her marriage, then went with her to her new home, a few doors down from her father. She has had four children. Their last name is Cnoll. Too often she is unwell.

My mistress Cornelia and I were walking outside for the first time after the long confinement of her lying-in with her fourth child, a daughter. I told her the news that I had just heard, that Ludolph had fallen ill one morning, with a stomachache, while in Batavia, and was dead by suppertime. He had eaten an entire large fish, they say, then fallen onto the floor. "Well," my mistress

said, "at least he had not to suffer for very long." I replied, "Perhaps not, but he will surely suffer where he's going!" She gave me one of her little sideways looks that I've come to know, and I said nothing more.

At that very moment, who should we see but Adriaen Gansvoort walking toward us. He had put on some weight, which suited him, and was still very handsome. I am told that he sat for his portrait with the painter Rembrandt van Rijn, who people say is always looking for strong, intelligent faces. My mistress, who had been leaning on my arm, paused as he came up, as if she were waiting for him or had even planned this meeting. But I had taken him no letter—that I know—and could not say where he lives now, if she had asked me to.

He took her hand, which was gloved, and held it for a moment in both of his, which were bare. With his fingertip, he felt the palm of my mistress's hand, as if searching for something through the kid leather. Looking up at her with a playful smile, he said, "You no longer have our bead in here." She nodded, also smiling. "No," she said and withdrew her hand, as she must. He touched the brim of his big hat to us both, nodding to me, and walked on. His hands were sunburnt and rough looking, as if he had been doing hard work with them. I had also been told that Adriaen Gansvoort had never married, but I did not speak to my mistress of that matter nor she to me. She has saved all his letters and keeps them in a little locked box with handles on it in her *kas*. Often, as I enter her room, I have found her reading them, but she quickly puts them away.

Captions:

Page 8, Francisco de Goya, *The Countess of Carpio, Marquesa de la Solana*, ca. 1794. Oil on canvas, 71¼ × 48 in. (181 × 122 cm). Musée du Louvre, Paris

Page 10, Dirk Hals, *The Merry Company* (detail), 1626. Oil on panel, 16¾ × 30½ in. (42.5 × 77.5 cm). Fine Arts Museums of San Francisco; Gift of Mr. and Mrs. Edward Carter

Page 11, Frans Pourbus the Younger, *Portrait of a Lady* (detail), 1591. Oil on panel, 39¼ × 29 in. (99.7 × 73.7 cm). Fine Arts Museums of San Francisco; Museum purchase, Roscoe and Margaret Oakes Income Fund

Page 14, attributed to Rembrandt van Rijn, *Man Reading* (detail), ca. 1648. Oil on canvas, 29³⁄₁₆ × 22⅛ in. (74.1 × 56.2 cm). Clark Art Institute, Williamstown, MA; Acquired by Sterling and Francine Clark, 1923

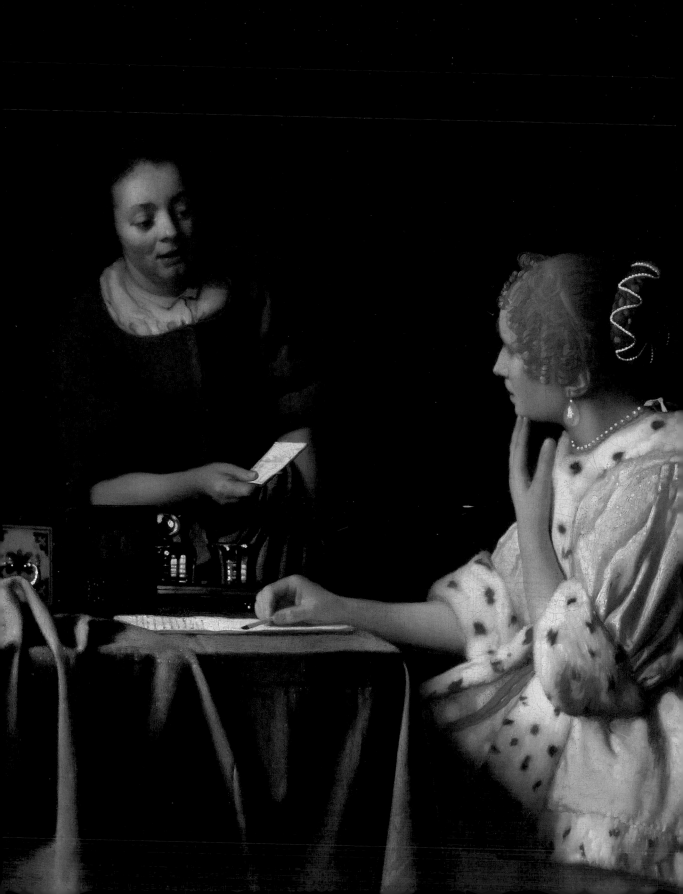

VERMEER'S MISTRESS AND MAID

Margaret Iacono

Even if you are closely watched, you will find the chance
To communicate to your lover through your maid.
You will have the chance to write back and forth.
Your little letters will go forth, and all remain hidden.

—Jacob Westerbaen, 1668

Fig. 1
Johannes Vermeer
Detail of *Mistress and Maid*,
1666–68
Oil on canvas
35 ½ × 31 in. (90.2 × 78.7 cm)
The Frick Collection, New York;
Henry Clay Frick Bequest

In the tense months following the official conclusion of World War I, Henry Clay Frick embarked on the purchase of Vermeer's *Mistress and Maid* (fig. 1) from a German collector. To do so, he was required to obtain a license from the War Trade Board as decreed by the Trading with the Enemy Act. In his 1919 application, Frick expressed his eagerness to acquire the work: "The painting by Vermeer . . . is an extremely valuable one and one that no doubt is sought by the art collectors of the world. I am anxious to secure it to add to the collection which I now have in my home in New York City."[1] Frick, whose collection of pictures and decorative art was by this time lauded by scholars and connoisseurs, was keen to add the painting to his holdings, which already included two works by Vermeer. The steel magnate's collection was particularly rich in pictures by Dutch artists, especially those active during the seventeenth century. Frick's first old master purchase, made in 1896, was by a Dutch painter, and while his aesthetic tastes would broaden over the course of his life to embrace artists from other schools, his admiration for Dutch Golden Age works remained constant.[2]

Mistress and Maid was the ninth authentic Vermeer to arrive on American shores, joining the two already in Frick's possession. Frick had acquired *Girl*

Interrupted at Her Music (fig. 2) in 1901, while still residing in Clayton, his Pittsburgh mansion. He purchased the canvas from Knoedler & Co. for $26,000, a steep price that demonstrates his eagerness to secure it. In 1911, he acquired *Officer and Laughing Girl* (fig. 3), a superlative example of the master's art, for an astounding $225,000. Frick did not often purchase multiple works by a single artist; so his decision to acquire three paintings by Vermeer speaks to his great enthusiasm for the Dutch master.

Vermeer chose a large canvas for his composition, which presents two women pondering a newly arrived letter. The seated woman, dressed in elegant attire, is dramatically lit by an unseen light source that illuminates her marble-like skin and yellow mantle. Set before her is a table spread with a cloth on which lie a sheath of paper, a veneered box, and a collection of glass writing accessories placed atop a silver tray. A modestly costumed maid emerges from the dark background to deliver a written message. The mistress's reaction, expressed by her hand stroking her chin, suggests her intense interest in the missive's arrival. The letter's inscrutable contents and the mistress's ambiguous response evoke a sense of mystery and uncertainty.

Depicting an interior domestic scene like so many of Vermeer's images, the painting explores the relationship between mistresses and maids and the writing and receiving of letters, two popular themes in the art and literature of the period. It also demonstrates Vermeer's technical virtuosity: bravura strokes suggest the pleating of the yellow mantle and the tablecloth's folds; shorter, bold strokes signify the flickering light reflected on the glassware; and dots of impasto convey the shimmer of the pearls.

The Sphinx of Delft

Johannes Vermeer (1632–1675) was born in Delft, a small but prosperous Dutch city boasting quiet canals, medieval spires, and a thriving beer industry; he would remain there for his entire life, apparently traveling only within the Dutch Republic. He was the second and youngest child of reformed Protestants Digna Baltens and Reynier Jansz. Vermeer. His father trained to weave caffa, an opulent silk cloth with printed or woven designs, before becoming an innkeeper and picture dealer, an occupation that likely introduced his son to local artists and collectors.

Little is known about Vermeer's life, thus his moniker "the Sphinx of Delft," but he probably began his artistic training in the mid-1640s. Several

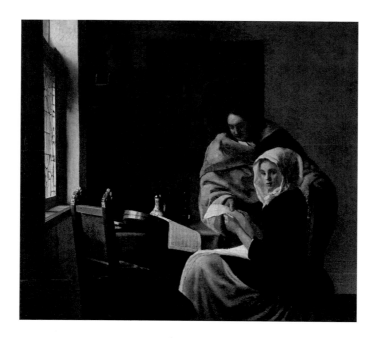

Fig. 2
Johannes Vermeer
Girl Interrupted at Her Music,
ca. 1658–59
Oil on canvas
15 ½ × 17 ½ in. (39.3 × 44.4 cm)
The Frick Collection, New York;
Henry Clay Frick Bequest

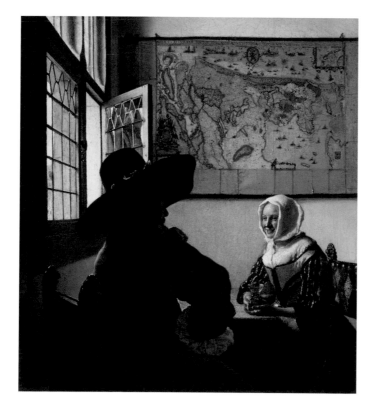

Fig. 3
Johannes Vermeer
Officer and Laughing Girl,
ca. 1657
Oil on canvas
19 ⅞ × 18 ⅛ in. (50.5 × 46 cm)
The Frick Collection, New York;
Henry Clay Frick Bequest

Fig. 4
Johannes Vermeer
A Maid Asleep, ca. 1656–57
Oil on canvas
34½ × 30⅛ in. (87.6 × 76.5 cm)
The Metropolitan Museum
of Art, New York; Bequest of
Benjamin Altman, 1913

artists, including Abraham Bloemaert (1566–1651) and Leonaert Bramer (1596–1674), have been proposed as possible mentors. Where he received his training is unknown, with Utrecht and Amsterdam both possibilities.[3] By December 1653, Vermeer was a member of the Delft Guild of St. Luke, a professional trade organization for painters, sculptors, and other artisans; he was elected *hoofdman* (headsman) of the guild in 1662 and again in 1670.[4] Guild membership granted him the right to sell his own paintings, as well as those of other artists, which supplemented his income and also kept him abreast of the work of fellow painters.

Vermeer married Catharina Bolnes (d. 1687) in April 1653, and they later moved into the home of Catharina's wealthy mother, Maria Thins. Financial support from Maria Thins must have been essential for Vermeer and his family, which would eventually include eleven children. Thins's assistance, together with the high prices Vermeer's pictures commanded and the income from his art dealing, probably accounts for the artist's small oeuvre. The family would later experience catastrophic financial hardship following the 1672 attack on the Dutch Republic by the French, the English, and the German bishoprics of Münster and Cologne. These pecuniary difficulties, experienced throughout the Dutch Republic as the economy crumbled, may have contributed to Vermeer's untimely death. His widow Catharina described his having been unable to sell either his paintings or those by other artists due to the war. This, she said, combined with the "great burden of his children . . . [caused him to fall] into such decay and decadence, which he had so taken to heart that . . . in a day or day and a half he had gone from being healthy to being dead."[5] Vermeer's death in 1675, at the age of forty-three, forced Catharina to declare bankruptcy. He could not have imagined the great sums *Mistress and Maid* would one day fetch or the important collections of which it would become a part.

Vermeer painted *Mistress and Maid* late in his career, about 1666–68, but the image recalls the introspective genre scenes of his earlier paintings, such as *A Maid Asleep* (fig. 4) and *Girl Reading a Letter at an Open Window* (fig. 5).[6] Here, however, the interior setting, a seminal element in the earlier works, is simplified in a way that heightens the powerful central interaction. Although scenes of mistresses and maids were prevalent in Dutch seventeenth-century art and identified by some scholars as being among the least expensive subjects, this is surely not the case with *Mistress and Maid*.[7] The mistress's fashionable attire and precious jewels imply that the picture was made for a person of means.

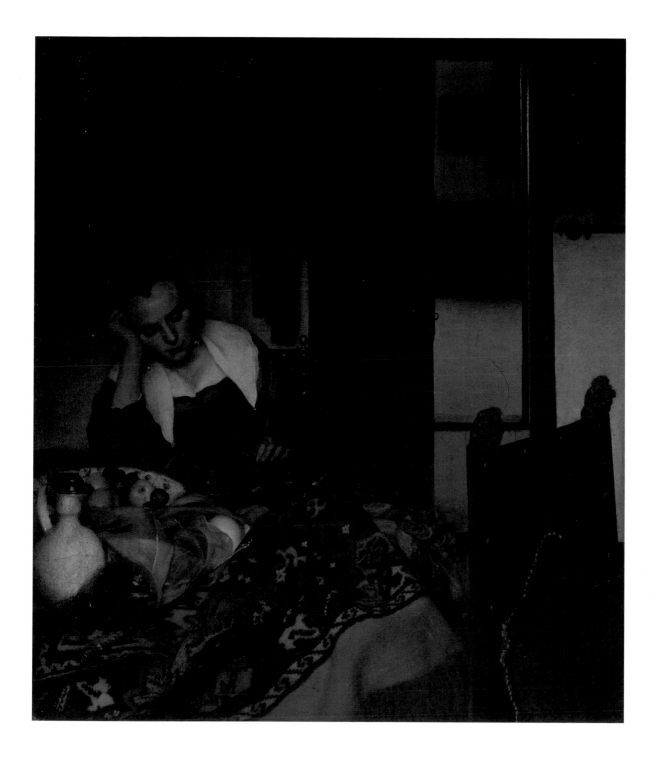

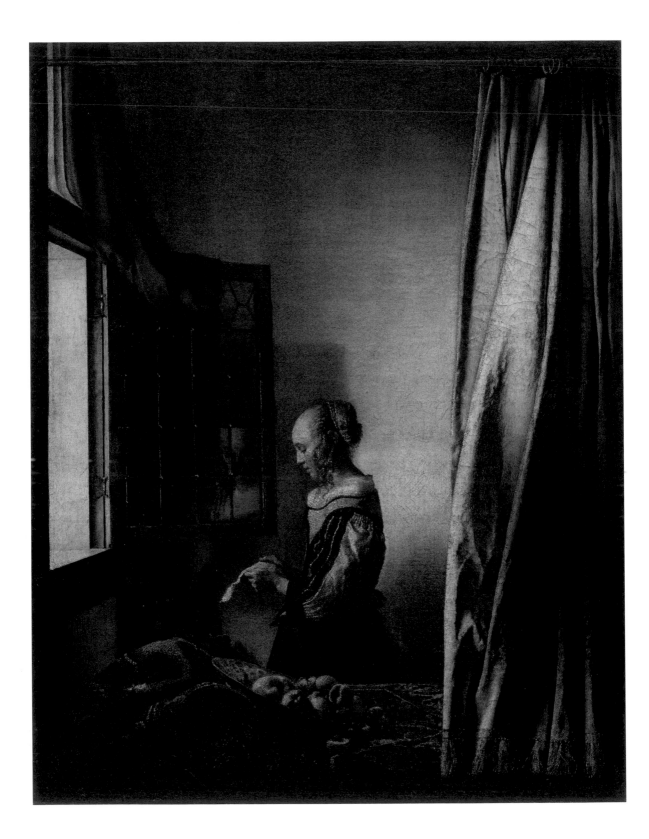

VERMEER'S MISTRESS AND MAID

The Maid Figure in Dutch Golden Age Pictures

The image of a maid and her mistress must have felt familiar to Frick, who employed about twenty servants to maintain his New York residence. The painting would also have represented a relationship known to many seventeenth-century Dutch viewers. Female servants were a conspicuous presence in Dutch homes. With so many men in maritime professions, the domestic labor force in the Dutch Republic was composed largely of women.[8]

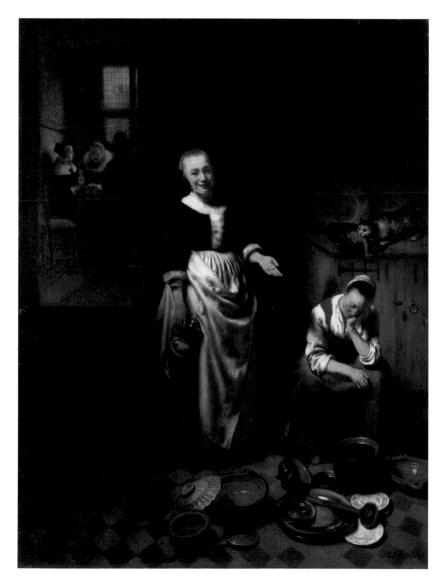

Fig. 5
Johannes Vermeer
Girl Reading a Letter at an Open Window, ca. 1657–59
Oil on canvas
32 ⅝ × 25 ⅜ in. (83 × 64.5 cm)
Gemäldegalerie Alte Meister, Dresden

Fig. 6
Nicolaes Maes
The Idle Servant, 1655
Oil on panel
27 ½ × 21 in. (70 × 53.3 cm)
National Gallery, London; Bequeathed by Richard Simmons, 1847

Fig. 7
Johannes Vermeer
The Milkmaid, ca. 1660
Oil on canvas
17⅞ × 16⅛ in. (45.5 × 41 cm)
Rijksmuseum, Amsterdam;
Purchased with the support of
the Vereniging Rembrandt

This differed considerably from other European countries at the time, like France and England, where household staffs were largely male. Statistics vary, but estimates suggest that between ten and twenty percent of Dutch households employed servants. Further departing from their counterparts in France and England, most Dutch residences had a single maidservant.[9] Women were responsible for supervising their domestic help and overseeing all other household affairs and were often portrayed in this way in the art of the period.[10]

Seventeenth-century representations of maids differ widely.[11] Nicolaes Maes (1634–1693), for example, depicts a woman napping at her duties in *The Idle Servant* (fig. 6). Vermeer's *A Maid Asleep* (see fig. 4) is a similar representation of indolence. Disparaging representations were common in stories and plays of the time, with maids often portrayed as conspiring with their mistresses in a variety of intrigues.[12] Female servants were cast as defiant, lustful creatures who stole or, worse, led their unsuspecting mistresses astray.[13] While such characterizations were no doubt exaggerations, the numerous ordinances passed in various cities in the Netherlands—one, for example, prohibited romantic relations between servants and family members and another penalized maids for gossiping—suggest a wary attitude toward domestic workers.[14] In reality, maids were more likely the victims of their powerful employers rather than the immoral figures of painting and fiction.[15]

Vermeer, in contrast to these negative portrayals, seems to depict the two women in *Mistress and Maid* as partners in the episode despite their different social status. The Dutch often treated their servants, especially those of longstanding employment, as family members. In some cases, servants dined with their employers and worked with their mistresses on household chores.[16] Maids occasionally testified on behalf of their mistresses in court, especially in cases of marital dispute.[17] Vermeer witnessed such loyalty in his own home when Tanneke Everpoel, a maid employed by his mother-in-law, Maria Thins, testified on behalf of her mistress regarding the actions of Thins's unstable son. Tanneke, who had been residing in the family home, had defended Vermeer's pregnant wife, Catharina, from a knife attack by her brother.[18]

Maids occasionally dressed similarly to their mistresses, as depicted in some contemporary paintings.[19] This blurring of class distinctions was found to be so reprehensible in Amsterdam, for example, that a series of sumptuary laws were passed in 1663.[20] Servants were forbidden to wear expensive textiles

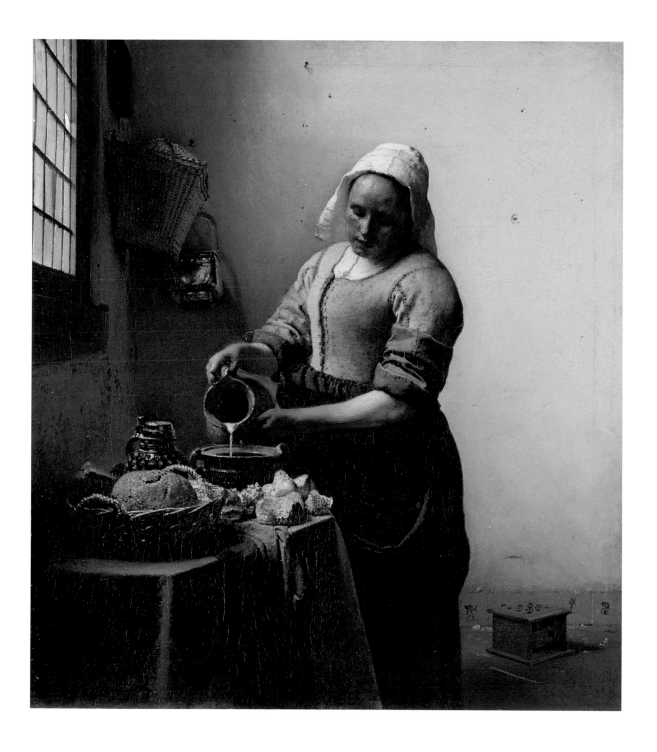

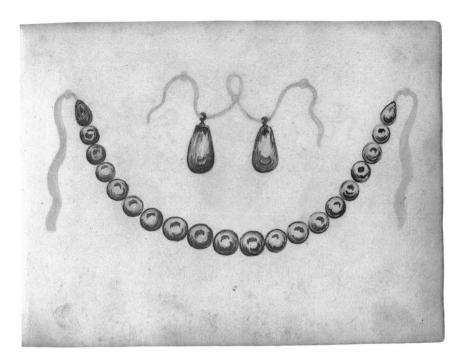

Fig. 8
Thomas Cletscher
Album with drawings and notes
by the jeweler, 1625–47
Watercolor and ink on paper
Sheet, 6¾ × 9 in. (17.1 × 23.1 cm)
Museum Boijmans Van
Beuningen, Rotterdam
(MvS 1a [PK])

like silk, velvet, and lace or precious metals and gemstones.[21] Vermeer, however, made certain that his audience would be able to identify his characters by their attire. The maid wears a simple brown wool bodice with an underlying chemisette, as well as an apron, in a deep blue meant to mask stains and similar to that worn by the woman in Vermeer's *Milkmaid* (fig. 7).[22] In the Frick painting, the rolled-up sleeves of the maid's bodice reveal a forearm lighter in color than her wrist and hand, indicative of her outdoor labors. Vermeer situates the painting's vanishing point on the maid's forearm—a key element and the means by which the letter is conveyed—while the mistress's arm, depicted in parallel counterbalance, further directs attention to the enigmatic letter.[23]

The mistress's costly clothes and elaborate hairstyle, adorned with seed pearls and secured by a velvet ribbon, make clear her social standing.[24] Another lustrous strand is tied around her neck, and a sizeable pearl dangles from her left earlobe. In Dutch paintings, such precious gems could serve as virtuous symbols of purity or vanitas warnings of extravagance, but their presence here likely indicates the woman's wealth.[25] Her earrings and necklace are strikingly similar to a set designed by the Hague jeweler Thomas Cletscher

(1598–1668) for Amalia van Solms (1602–1665), wife of Frederik Hendrik, Prince of Orange (1584–1647) (fig. 8).[26] While the iridescence of the jewels is consistent with true pearls, they are more likely to be glass or polished silver or tin, which were also much in vogue. The cost of pearl earrings of that size would have been astronomical.[27]

The mistress's yellow satin jacket, known as either a *jak* or *manteltje*, was an informal item worn by middle- and upper-class women for warmth inside the home. A jacket of this description was recorded in the 1676 inventory of Vermeer's estate and probably belonged to his wife.[28] Catharina's possession of this mantle, her documented literacy, and her approximate age in the later 1660s have led some scholars to propose her as the model for the mistress figure, a suggestion that, however appealing, cannot be proven.[29] Although the black-spotted white trim found on the garment looks like ermine, it would more likely have been white squirrel or cat fur, both commonly used.[30] Ermine, which appears on royal ceremonial robes and thus has aristocratic associations, was rare and expensive.

The mistress's affluence is further underscored by the glass and silver writing set, the veneered box, and the tablecloth, which may have been inspired by objects in Vermeer's home. Technical studies undertaken for this publication—and discussed more fully below—find that the tablecloth, which now appears blue, was originally green. Its blue appearance is most likely a result of pigment degradation over time.[31] As Vermeer's estate inventory includes a green tablecloth, as well as a box with ebony veneer, it seems probable that he modeled elements of his composition after objects in his possession.[32]

The Epistolary Theme

In the Dutch Republic, there was a high level of literacy compared with the rest of seventeenth-century Europe. Letter writing was particularly fashionable with the middle and upper classes, but members of the laboring classes also often attained some level of writing proficiency.[33] The epistolary theme became a popular subject for painters and writers in the Dutch Republic after about 1650. The letter motif in *Mistress and Maid* reflects this interest and was inspired by the work of earlier artists. The oeuvre of Gerard ter Borch the Younger (1617–1681) was particularly rich in such representations, a sub-genre of his popular scenes

depicting fashionable *juffertjes* (young ladies). Ter Borch is credited with at least sixteen works featuring letter imagery; his *Woman Writing a Letter* (fig. 9) is the earliest extant example of this type.[34] Elegantly arrayed and wearing a prominent pearl earring, the subject is completely engrossed in her writing. We cannot confirm that Vermeer knew this work, but as a dealer, he must have been aware of some of the letter pictures by this prominent artist.

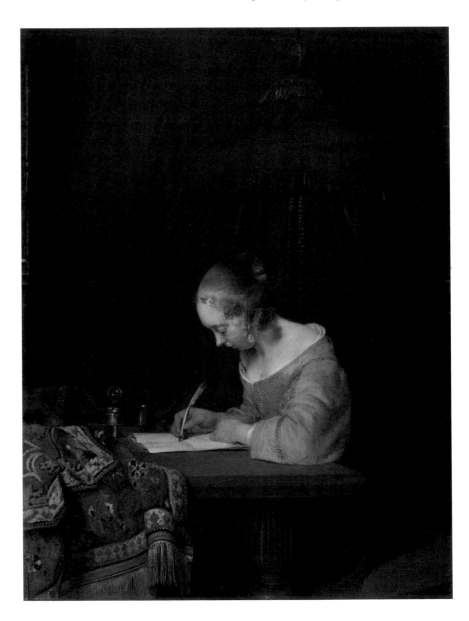

Fig. 9
Gerard ter Borch
Woman Writing a Letter,
ca. 1655
Oil on panel
15 ⅛ × 11 in. (38.3 × 27.9 cm)
Mauritshuis, The Hague

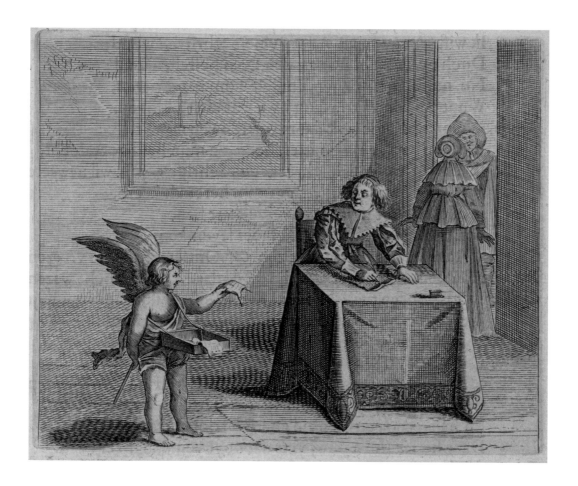

Records suggest that the two men knew each other: a document in the Delft archives records their joint signing as witnesses for an act of surety in April 1653. Its date, just two days after Vermeer's wedding, has led some to suggest that Ter Borch visited Delft to attend the younger artist's nuptials.[35] While *Mistress and Maid* was executed more than a decade after *Woman Writing a Letter*, it clearly draws on the letter-writing tradition promoted by Ter Borch.

Letter images were typically associated with romantic escapades. Contemporary etiquette manuals, literature, and theater likely inspired any romantic allusions in *Mistress and Maid*. An illustration accompanying "Rozemond," a dramatic piece by the Dutch playwright Jan Harmensz. Krul—included in his book *Pampiere Wereld* (Paper World) of 1644—is interesting to consider. Titled *Cupid Presenting a Letter to a Maid* (fig. 10), it bears a certain similarity to Vermeer's scene.[36] Here, the diminutive god of

Fig. 10
Cupid Presenting a Letter to a Maid. From Jan Harmensz. Krul, *Pampiere Wereld, ofte Wereldsche oeffeninge, waer in begrepen zijn meest alle de rijmen, en werken, van I. H. Krvl* (Amsterdam, 1644), vol. 2, p. 81
Image, 4¼ × 5¼ in. (10.6 × 13.2 cm)
Columbia University in the City of New York, Rare Book & Manuscript Library

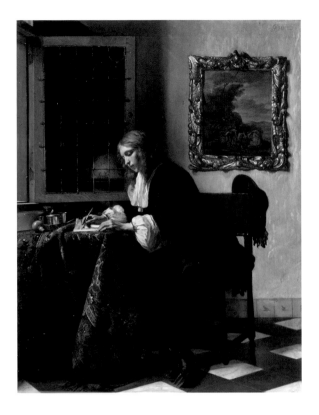

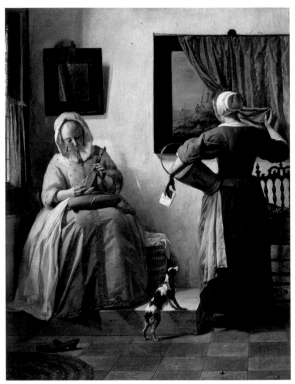

Fig. 11
Gabriel Metsu
Man Writing a Letter, 1664–66
Oil on panel
20⅝ × 15⅞ in. (52.5 × 40.2 cm)
National Gallery of Ireland
Collection, Dublin; Presented,
Sir Alfred and Lady Beit, 1987
(Beit Collection)

Fig. 12
Gabriel Metsu
Woman Reading a Letter,
1664–66
Oil on panel
20⅝ × 15⅞ in. (52.5 × 40.2 cm)
National Gallery of Ireland
Collection, Dublin; Presented,
Sir Alfred and Lady Beit, 1987
(Beit Collection)

love delivers a letter to a young woman, who is writing at a table. According to Krul, she epitomizes "maids who fall in love but have no sense." Vermeer's mistress may be similarly engaged in a love affair, with the maid playing an active role in its progression, a cupid of sorts.

Objects in *Mistress and Maid* may offer further clues for understanding the narrative. The casket on the desk, for example, has been identified as an import from Goa in western India.[37] The presence of such a luxury item further underscores the mistress's affluence. Although often identified as a jewelry box, it may also be a writing cabinet for storing writing accessories and perhaps love letters.

The mistress's composing of one letter while receiving another has led some scholars to posit that more than one suitor might be competing for her affections.[38] Others have suggested that the sender of the newly arrived message might be the addressee of the mistress's own epistle.[39] The writing and receiving of messages was portrayed earlier by Gabriel Metsu (1629–1667) in his pendant works *Man Writing a Letter* (fig. 11) and *Woman Reading a*

Letter (fig. 12). In *Man Writing a Letter*, a young man crafts a note while a woman reads another in the corresponding panel. The attendant maid, who pulls back a curtain to gaze at a stormy seascape, holds a separate folded letter that the young mistress presumably composed before receiving the post she now studies.

Another painting by Metsu shares compositional elements with Vermeer's *Mistress and Maid*. As in the Frick painting, *The Note* (fig. 13) presents an elegantly clad mistress in profile and seated at a cloth-covered table. She hands a letter to her maid, who is emerging from the dark to collect it. In the maid's hand is another missive, either ready to be posted or recently delivered.[40] The presence of a curtain behind the seated woman, discovered when the panel was examined under infrared light, is another compositional feature with a correspondence in the Frick painting.[41] The many similarities make

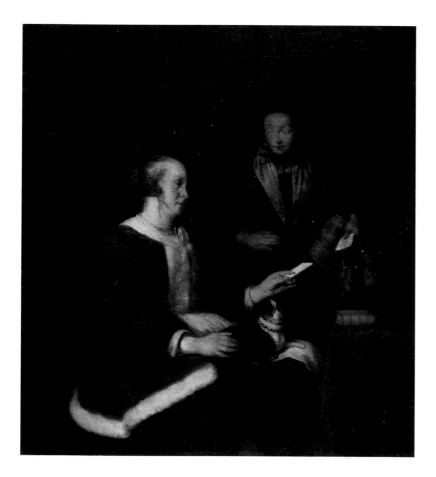

Fig. 13
Gabriel Metsu
The Note, ca. 1657–59
Oil on panel
12 ¾ × 11 ¾ in.
(32.39 × 29.85 cm)
The Walters Art Museum,
Baltimore; Acquired by Henry
Walters, 1925

Fig. 14
Johannes Vermeer
Woman in Blue Reading a Letter,
ca. 1663
Oil on canvas
18¼ × 15⅜ in. (46.5 × 39 cm)
Rijksmuseum, Amsterdam; on
loan from the City of Amsterdam
(A. van der Hoop Bequest)

one wonder if Vermeer had seen the Metsu picture before painting *Mistress and Maid.* The compositions' resemblances may also simply demonstrate the popularity of mistress and maid scenes and epistolary images with Dutch artists, and their patrons, at this time.

Vermeer's Literary Ladies

Contemporaneous paintings of letter writers and letter readers surely influenced Vermeer when painting *Mistress and Maid,* but this work also relates to the artist's earlier representations of these themes. In *Girl Reading a Letter at an Open Window* (see fig. 5), a young woman in silhouette, absorbed in the flimsy sheet in her hands, faces an open casement. A flood of sunlight reflects her face in the window's glass. A carpet-covered table and an open curtain, placed close to the picture plane, create a visual barrier isolating the girl from the viewer. Several years later, Vermeer returned to the theme in *Woman in Blue Reading a Letter* (fig. 14), again presenting a woman in silhouette. Daylight envelops her figure, its swelling form possibly indicating pregnancy. The map behind her might allude to the distant whereabouts of the letter's author, perhaps her child's father. Despite these possible clues, the letter's contents and the woman's story remain unknown.

A Lady Writing (fig. 15), painted a few years after *Woman in Blue*, presents a more dynamic image. Unlike her passive counterparts in the previous paintings, this young woman is actively composing a letter and pauses to look out toward the viewer. Her yellow jacket and weighty pearl earrings, along with the tablecloth and the wooden box, reappear in the Frick painting. Intrusion, in the form of a letter or person, is a common leitmotif in these images, one that Vermeer will portray again in two later works.

The Love Letter (fig. 16) depicts a seated woman holding a note that presumably was just delivered by the maid standing behind her. Its appearance interrupts the mistress's cittern playing and causes her to look toward her servant, who smiles reassuringly. The figures' costumes and the picture's narrative are familiar, but Vermeer embellishes the setting with paintings, gilded wall panels, a fireplace, and a marbled floor. Details like the disheveled pile of sheet music and the cittern, symbolic of courtship, as well as the full laundry basket and broom, may hint at the neglect of domestic duties in favor of romantic pursuits and suggest the letter's unexpected arrival. Particularly interesting is the *doorkijkje*, the sophisticated frame through which the viewer

Fig. 15
Johannes Vermeer
A Lady Writing, ca. 1665
Oil on canvas
17 11/16 × 15 11/16 in.
(45 × 39.9 cm)
National Gallery of Art,
Washington; Gift of Harry
Waldron Havemeyer and Horace
Havemeyer, Jr., in memory of
their father, Horace Havemeyer

glimpses the private moment. These painted architectural elements, literally "see-through" doorways, allowed artists to demonstrate their technical prowess while adding a hint of voyeurism to the scene.

In *A Lady Writing a Letter with Her Maid* (fig. 17), the last of Vermeer's three mistress and maid scenes, a woman is writing at a desk, perhaps in response to the crumpled sheet of paper cast upon the floor, its seal and wrapper beside it. Once again, Vermeer situates his figures in an opulent interior. Unlike the women in the two earlier works, however, these figures do not interact; the maid gazes out the window while the mistress focuses on her writing. Still, *Mistress and Maid* is recalled by the woman's epistolary task and the maid, who resembles the servant in the Frick painting.[42]

From the inert, stoic figures in *Girl Reading a Letter at an Open Window* and *Woman in Blue Reading a Letter* to the confronting gaze of the subject in *A Lady Writing* and the emphatic gestures and emotional expressions of the woman in his maid scenes, we see Vermeer's figures becoming increasingly animated. By introducing a second character in the figure of a servant, Vermeer adds another layer of complexity to the letter theme. The sophisticated interior settings of *The Love Letter* and *A Lady Writing a Letter with Her Maid* likewise enrich these scenes. However, while the two later maid pictures are compositionally more detailed than *Mistress and Maid*, they lack the intensity of the psychological exchange depicted in the Frick canvas.

Mistress and Maid from a New Perspective

Vermeer revisited themes, character types, and costumes from his earlier works when creating *Mistress and Maid*; nevertheless, the picture is a departure from his previous compositions. Its large size and nebulous background have caused some to undervalue the work. In 1864, for example, Sir Charles Eastlake (1793–1865), then director of the National Gallery in London, attempted to acquire the painting for the museum's collection despite concerns that the setting was too dark and the picture too large for a "familiar, unimportant scene." The half-hearted, low offer he submitted was rejected.[43]

The picture's proportions and dark background may be clues to the circumstances of its creation. It is not the only sizeable painting from this period; however, it is larger than many other works Vermeer made during the mid- to late 1660s. The generous scale, which makes it an unlikely candidate for the open art market, may indicate that it was commissioned

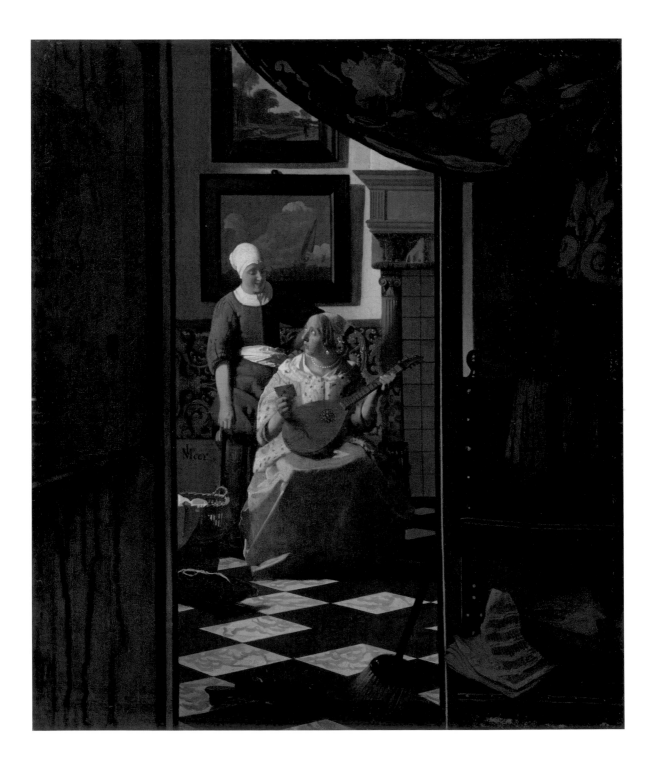

for a specific setting.[44] Arthur Wheelock observes that the figure of the mistress is "disproportionately large."[45] Walter Liedtke likewise acknowledges this peculiarity and posits that the canvas may have been hung higher than Vermeer's smaller pictures, causing the large scale of the figures to be less pronounced.[46] This lends credence to the idea that Vermeer created the work for a specific location.

Most of Vermeer's interior compositions feature a window as a source of illumination. In *Mistress and Maid,* light enters the room from the left, presumably through a window or windows visible only in the reflections cast in the ink wells. The painting may have been created with the intention of installing it to the right of these windows. Sunlight streaming through them is not only reflected in the glass vessels but also illuminates the maid, the letter she holds, the tabletop, and, most important, the mistress. It was not uncommon for the placement of a painting to be determined before its creation. As Pieter Fransz. de Grebber noted in his treatise of 1649 on the rules of painting, "there are various reasons for knowing where a piece (painting) will hang before it is made; for the light; for the height at which it will hang; in order to distance our position and horizon."[47]

An observed lack of modeling, especially in the mistress's profile and hands, is a feature that has caused some scholars to declare the picture unfinished.[48] While the figures are not as highly finished as in earlier paintings in Vermeer's oeuvre, this assessment stems from a misunderstanding of the artist's stylistic evolution.[49] In order to put *Mistress and Maid* in context, it is important to understand Vermeer's techniques during this period. Wheelock's analysis corroborates the canvas's dating to the later 1660s by identifying characteristics found in other Vermeer paintings from later in his career. He convincingly refutes assertions that the picture was left unfinished.[50] It seems that Vermeer intentionally executed certain elements—like the mistress's profile, her eye, and hands—in a less precise manner. The soft articulation of her form imbues the figure with a sense of movement—her mouth open and on the verge of speech, her hand rising to her chin in thought, her eye addressing the maid and at the same time gazing past her. The maid's extended hand is also painted in an indistinct manner that likewise implies animation. In modern terms, one may think of the blur of a moving object when captured in a still image.

Unlike the compositions from his early career—in which he applied pigment in thick layers—Vermeer's later works reflect a more nimble handling

Fig. 16
Johannes Vermeer
The Love Letter, ca. 1667–70
Oil on canvas
17⅜ × 15⅛ in. (44 × 38.5 cm)
Rijksmuseum, Amsterdam;
Purchased with the support of
the Vereniging Rembrandt

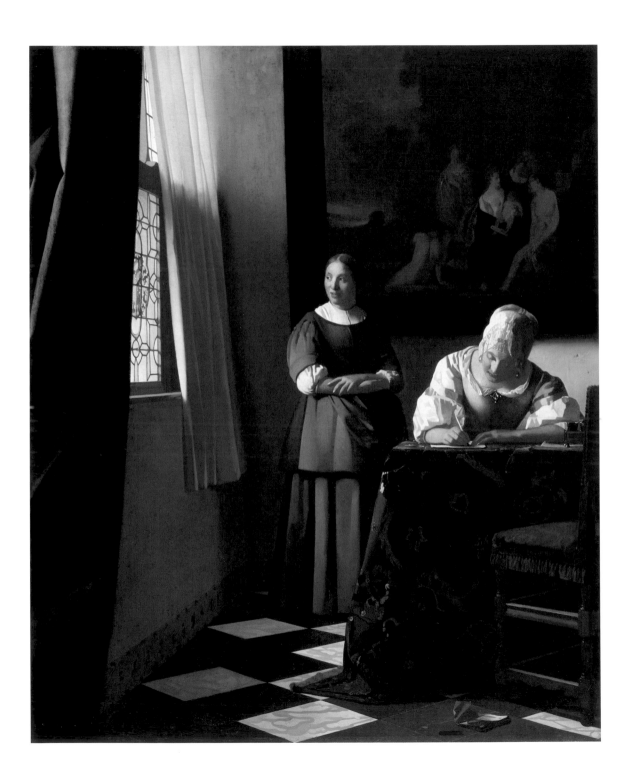

of paint, with some passages so thinly applied that the underlying ground appears. This is another feature that has led some to view *Mistress and Maid* as unfinished. After priming his canvas with a light-colored ground, Vermeer apparently applied a brown-black layer.[51] Current technical analyses of the painting suggest that this black-brown layer seems to have been restricted to specific areas where Vermeer blocked in his composition and undermodeled his figures in neutral tones of brown and black.[52] He then applied his upper paint layers more thinly, allowing the dark preparatory layer to assist him in modeling his forms. This dark underlayer also helped establish the tone of the image and intensified the illumination of the figures and objects in the scene.

Mistress and Maid shares certain features with other Vermeer pictures, such as his *Girl with a Pearl Earring*, painted slightly earlier (fig. 18). Here, Vermeer sets his subject against an undefined backdrop to focus attention on the girl as she turns to gaze at the viewer.[53] Unlike that in the *Girl*, the background in *Mistress and Maid* includes remnants of a drawn curtain. The authenticity of this swathe of material once sparked considerable controversy among scholars because it is absent from a line engraving made after the picture in the nineteenth century by its then owner, the art dealer Jean-Baptiste-Pierre Lebrun (1748–1813) (see fig. 23). Critics question whether the curtain is absent because Lebrun considered it inessential and therefore omitted it or because it was added after the canvas left his possession. This question was resolved by Frick conservator William Suhr, who, in 1952–53, concluded, "The background *is* original and *is* a curtain." Suhr's analysis did, however, find evidence of later repainting in several areas, including in what appeared to be traces of Vermeer's signature across the top of the shadowed side of the casket on the table. After confirming that this signature was spurious, Suhr removed it.[54]

Recent technical studies, undertaken by Dorothy Mahon and Silvia A. Centeno of the Metropolitan Museum of Art, have revealed important new information about *Mistress and Maid*'s initial appearance and Vermeer's painting techniques.[55] Pigment analyses indicate that originally the curtain was probably a translucent dark green. Its current faint brown color is the result of the pigments having darkened over time. Pigment degradation also accounts, in part, for the relative loss of depth and form of the curtain.[56]

The appearance of the tablecloth has also changed. Much as with the curtain, the tablecloth was originally green but lighter and more richly colored.

Fig. 17
Johannes Vermeer
A Lady Writing a Letter with Her Maid, ca. 1670
Oil on canvas
28 × 23⅞ in. (71.1 × 60.5 cm)
National Gallery of Ireland, Dublin; Presented, Sir Alfred and Lady Beit, 1987 (Beit Collection)

Fig. 18
Johannes Vermeer
Girl with a Pearl Earring,
ca. 1665
Oil on canvas
17½ × 15⅜ in. (44.5 × 39 cm)
Mauritshuis, The Hague

Further, the pigment mixtures and construction of the curtain and tablecloth differ, suggesting that they would have appeared as different fabrics.[57] The tablecloth's shadows, composed largely with green pigments, have darkened and discolored, causing it to appear blue. A considerable amount of ultramarine blue—made by grinding the semi-precious lapis lazuli stone—has been identified in the composition. Extensive use of this costly pigment is also found in other paintings by Vermeer.[58] Current research indicates that the pigment was especially favored by painters of high-life subjects, its vibrant hue befitting the elegant costumes and luxurious interiors of these scenes.[59]

Like many artists, Vermeer made modifications in the course of developing his compositions. New infrared reflectography (IRR) of the canvas is particularly revealing as it shows that Vermeer included a highly detailed, multi-figural pictorial element in the background that he later painted out (fig. 19). This section likely represented a large tapestry or painting on the wall behind the figures.[60] *Mistress and Maid* would have appeared strikingly different had Vermeer retained this pictorial element in the final composition. After deciding that a relatively dark and plain background would better focus on the woman's interactions, he added the curtain, drawn aside to direct attention on the letter's receipt.

Vermeer often made numerous changes to his compositions, as he did, for example, in *A Maid Asleep* (see fig. 4). An X-radiograph of the canvas reveals the figure of a man in the rear room, as well as a dog at lower right. Vermeer painted out both figures as the composition evolved. He also altered the still life on the table considerably as the painting progressed.[61] Such compositional changes were typical of the artist's working process.

Vermeer frequently embellished his painted interiors with maps, mirrors, paintings, and tapestries. Some seem to comment on the narrative, as in *Woman Holding a Balance* (fig. 20), where the woman's action is contrasted with a large Last Judgment painting on the wall behind her, probably symbolizing the weighing of souls and meant as an appeal for temperance. In other cases, like *Girl with the Red Hat* (fig. 21), painted slightly before *Mistress and Maid*, a section of a tapestry is visible, but its fairly broad rendering and the extent to which it is obscured by the figure suggest that Vermeer intended it for decorative, not iconographic, purposes.

The hypothesis that the original figural elements in the background of *Mistress and Maid* were from a tapestry would explain the vertical section to

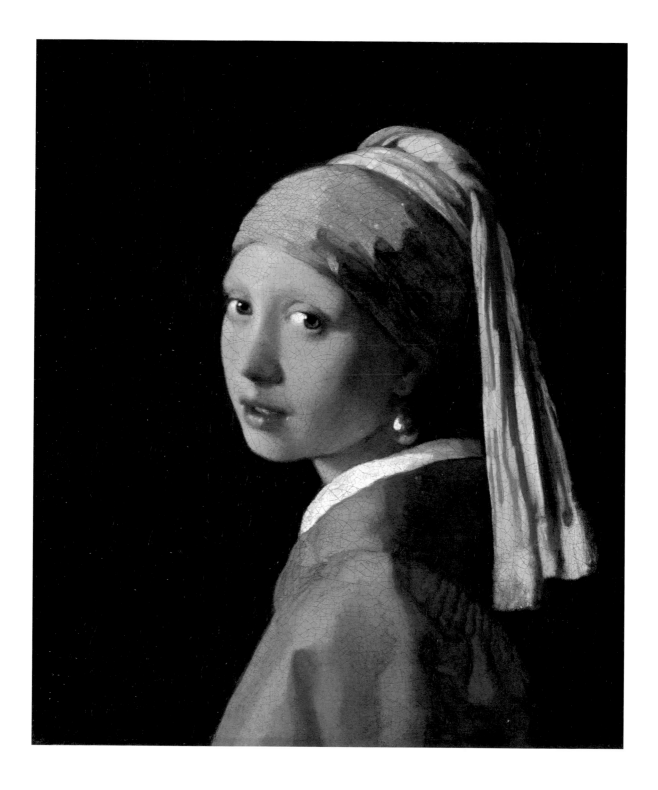

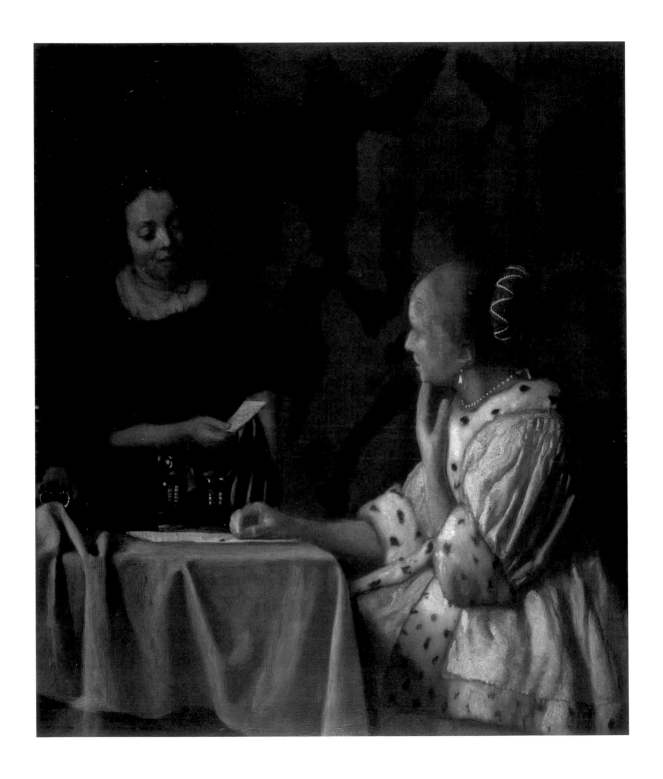

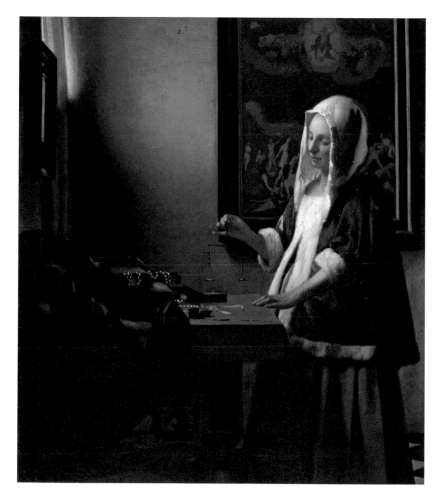

Fig. 19
IRR image of *Mistress and Maid*

Fig. 20
Johannes Vermeer
Woman Holding a Balance,
ca. 1664
Oil on canvas
15 ⅝ × 14 in. (39.7 × 35.5 cm)
National Gallery of Art,
Washington; Widener Collection

Following pages:
Fig. 21
Johannes Vermeer
Girl with the Red Hat,
ca. 1665–66
Oil on panel
9 × 7 ⅟₁₆ in. (22.8 × 18 cm)
National Gallery of Art,
Washington; Andrew W. Mellon
Collection

Fig. 22
Workshop of Jan van Leefdael,
after a design by Jacob Jordaens
Four Servants, ca. 1650
Tapestry
167 ¼ × 138 ¼ in.
(424.8 × 351.2 cm)
The Art Institute of Chicago;
Gift of Charles L. Singer through
the Antiquarian Society

the far right of the design evident in the reflectogram. This section seems to depict a sculpture in a niche and would make sense as an elaborate border surrounding the tapestry's central scene.[62] Although the original source of Vermeer's inspiration for the background has not been identified, a Flemish tapestry woven after designs by Jacob Jordaens (1593–1678) is a useful comparative (fig. 22). Here one finds a robust female figure in a posture reminiscent of the one visible in the IRR image near the mistress's profile (see fig. 19). Hanging garlands and borders populated with statues also correspond to elements discernible in the IRR. Whatever this intricate design was intended to depict, Vermeer apparently felt it distracted from the central narrative and edited it out of the final composition.

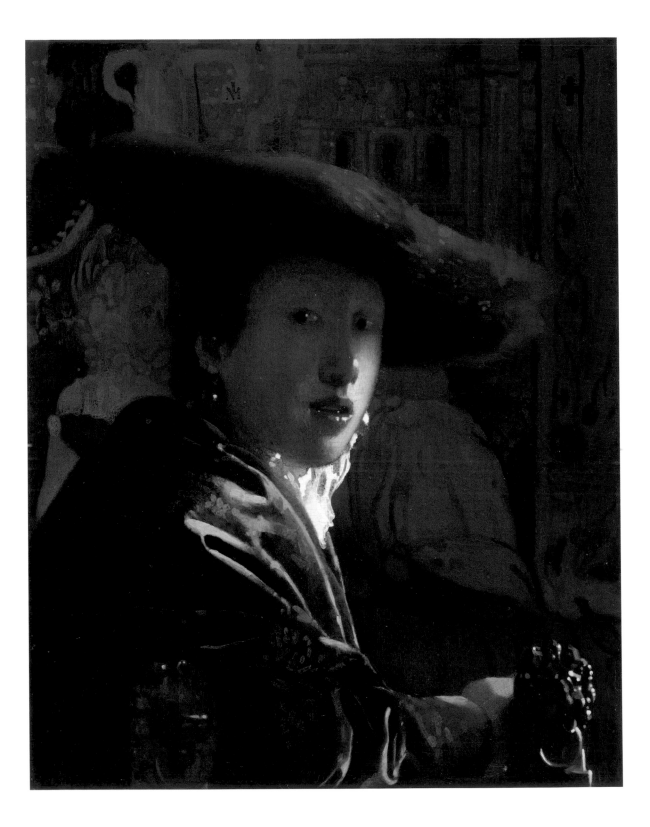

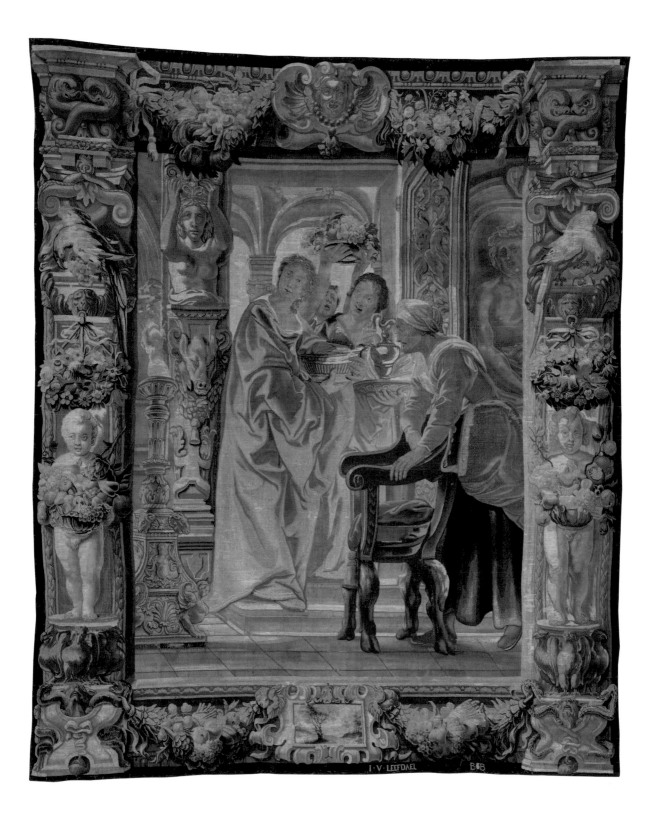

I · V · LEEFDAEL B᛫B

A Peripatetic Painting

After *Mistress and Maid* left Vermeer's studio, it would be owned and appreciated by an international group of collectors, the most notable of whom are mentioned here.[63] In the absence of corroborating documents, the identity of the painting's first patron cannot be confirmed. Pieter Claesz. van Ruijven (1624–1674) and his wife Maria Simonsdr. de Knuijt (d. 1681) of Delft have been proposed as likely candidates by several scholars.[64] The couple collected paintings by other Dutch artists, like Emanuel de Witte (1617–1692) and Simon de Vlieger (ca. 1601–1653), but their holdings seem to have been particularly rich in pictures by Vermeer, with as many as twenty-one once in their possession.[65]

Born into a distinguished and affluent family, Van Ruijven lived in Delft for many years. He and his wife must have acquired their wealth through inheritance and investments since no occupation is attributed to him, but he held a post with the Camer van Charitate, a municipal institution devoted to helping the poor. Van Ruijven was also a member of Delft's elite civic guard, as was Vermeer.[66] John Michael Montias contends that Van Ruijven and De Knuijt were patrons and close associates of Vermeer and suggests that the couple had an understanding with the artist granting them first right of refusal for his pictures. This proposal was partially inspired by documents recording Van Ruijven's 1657 loan to Vermeer of 200 guilders. De Knuijt's later bequest of 500 guilders to the artist in 1665, as well as Van Ruijven's witnessing of Vermeer's sister's testament in 1670, support speculation that he was an intimate acquaintance of the family.[67]

If Van Ruijven and De Knuijt were the first owners of *Mistress and Maid*, it likely would have passed to Magdalena van Ruijven, their daughter and sole heir, upon De Knuijt's death. When Magdalena died one year later, in 1682, her parents' art collection was divided between her husband, Jacob Abrahamsz. Dissius, and her father-in-law, Abraham Dissius. The historic Dissius sale, held in Amsterdam in May 1696 after Jacob Dissius's death in 1695, is generally thought to have included *Mistress and Maid* among the twenty-one paintings by Vermeer. Confusion over the painting's early provenance stems from its cursory mention in the sale's catalogue—"Een Juffrouw die door een Meyd een brief gebragt word" (A young woman to whom a letter is brought by a maid)[68]—a description that could also apply to Vermeer's *Love Letter* (see fig. 16). In the absence of corroborating documentation, many scholars

believe that the catalogue refers to *Mistress and Maid*, as certain noteworthy elements in *The Love Letter* are not mentioned.

Montias did not include *Mistress and Maid* among those paintings by Vermeer in Van Ruijven's possession, proposing instead that the Delft baker Hendrick van Buyten (1632–July 1701) was the owner.[69] Although the description in Van Buyten's estate inventory—"representing two persons one of whom is sitting writing a letter"—fits the Frick painting, it also could describe Dublin's *Lady Writing a Letter with Her Maid*. Montias assumed that *Mistress and Maid*'s dark background reflected its incomplete state. Based on this assumption, he proposed that the canvas was in Vermeer's possession at the time of his death and was thus one of the paintings given by his widow to Van Buyten in partial payment for the family's bread debt. However, Suhr's study and the recent investigations by Mahon and Centeno confirm that the painting is finished. Wheelock similarly doubts Van Ruijven's ownership of the picture. He finds the work's character dissimilar enough from others thought to have been in Van Ruijven's collection to suggest a different patron.[70]

Despite uncertainties over the picture's early ownership, records show that it was part of the estate of the wealthy Amsterdam collector and gun maker Jacob Oortman (1661–1738), although it is unknown when Oortman purchased the painting. Oortman's son, Hendrik Oortman (1696–1748), acquired the painting at the sale of his father's collection.[71] Admiration for Vermeer's pictures grew during the nineteenth century, especially after 1822, when the artist's *View of Delft* was purchased by the Dutch government and installed in the Mauritshuis in The Hague.[72] The mid-century championing of Vermeer's oeuvre by critics like French connoisseur Théophile Thoré (1807–1869), who wrote under the pseudonym William Bürger, further enhanced the reputation of the master's paintings.[73]

During the nineteenth century, *Mistress and Maid* passed through a series of French collections, notably that of the art dealer Jean-Baptiste-Pierre Lebrun, grandnephew of the celebrated artist Charles Lebrun (1619–1690) and husband of the painter Elisabeth Louise Vigée (1755–1842). Lebrun was also trained as a painter, but he is best remembered as an eminent connoisseur whose expertise in Flemish, Dutch, and German paintings culminated in his *Galerie des peintres flamands, hollandais et allemands* (1792–96), a seminal work that recognized Vermeer's genius. In 1809, Lebrun published the aforementioned line engraving (fig. 23) of *Mistress and Maid* in his *Recueil*

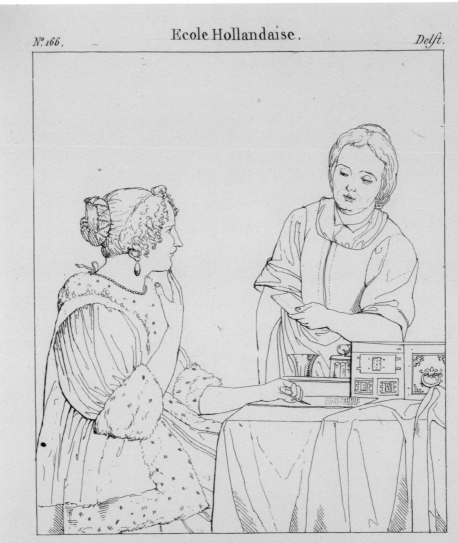

VANDER MEER de Delft, P.ˣⁱᵗ

hauteur 33 pouces, largeur 29 pouces, sur Toile.

de gravures au trait, a series of simple engravings made after paintings he had purchased between 1807 and 1808.

Vermeer's painting was also part of the collection of Marie-Caroline de Bourbon-Sicile, Duchess of Berry (1798–1870), an Italian princess who joined the French royal family when she married Charles Ferdinand, Duke of Berry (1778–1820), nephew of Louis XVIII. The duke and duchess were fervent patrons of the arts and assembled an important ensemble of artworks. *Mistress and Maid* joined yet another illustrious collection when it was acquired by the copper industrialist Eugène Secrétan (1836–1899), whose acclaimed assemblage of paintings included numerous important Dutch and Flemish pictures. Secrétan sold *Mistress and Maid* in the Paris gallery of Charles Sedelmeyer, when the copper crash of 1889 forced him into bankruptcy. The canvas then entered the collection of A.A. Paulovstof in St. Petersburg, Russia.

By 1905, the painting was in London with A.J. Sulley & Co. and was exhibited prominently in its gallery in New Bond Street, London.[74] One notice mentioning Sulley's display deemed *Mistress and Maid* "good enough to draw all the connoisseurs to Bond Street"[75] and noted that a picture by Vermeer "now commands a very high price."[76] By 1906, the painting was in Berlin in the possession of James Simon (1851–1932), a German Jewish textile magnate, philanthropist, and close friend of the emperor Wilhelm II. Simon had an avid interest in art and archaeology; most of his magnificent collection was eventually donated to the Berlin State Museums, though some works were sold.

Henry Clay Frick purchased *Mistress and Maid* from Simon's collection with the assistance of several dealers. In September 1919, when word got out that Frick had acquired his third Vermeer, newspapers mistakenly identified the new acquisition as *The Art of Painting* (now in the Kunsthistorisches Museum, Vienna) or *The Glass of Wine* (then and now in the Gemäldegalerie, Berlin).[77] Despite the many hands involved in this transaction, the painting's identity seems to have remained a secret until it was in Frick's possession.

A Circuitous Route to The Frick Collection

The acquisition of *Mistress and Maid* was complicated, and the specifics of the painting's procurement, pieced together from material gathered from several archives, are published here for the first time.[78] Previous publications,

Fig. 23
Jean-Baptiste-Pierre Lebrun, line engraving after Vermeer's *Mistress and Maid*. From *Recueil de gravures au trait, à l'eau forte, et ombrées, d'après un choix de tableaux de toutes les écoles, recueillis dans un voyage fait en Espagne, au Midi de la France, et en Italie, dans les années 1807 et 1808* (Paris: Didot Jeune, 1809), no. 166
Image, 5 × 4¼ in.
(12.7 × 10.8 cm)
The Frick Art Reference Library, New York

including the Frick's own catalogue published in 1968, have incorrectly credited M. Knoedler & Co. for the sale to Frick,[79] and numerous catalogues raisonnés have repeated this part of its provenance.[80] More recently, M.J. Ripps discovered that Knoedler was not involved in the painting's sale; instead, he identified the Dutch dealer Abraham Preyer as the sole agent.[81] Building on Ripps's findings, new evidence reveals that the sale of *Mistress and Maid* to Frick was the result of the combined efforts of Preyer and a number of other dealers.

Frick's endeavor to secure the coveted picture in 1919 was preceded by another attempt some five years earlier. In May 1914, the art dealer Arthur Joseph Sulley (1853–1930) had, at Frick's behest, contacted James Simon "and asked him if he could be tempted to sell his Vermeer, and what he would think of an offer of £50,000" (approximately $250,000). According to Sulley, Simon adamantly declined, adding that "no offer would tempt him to sell the Vermeer, and that he has already refused an offer of £50,000 several times."[82]

In the early months of 1919, the painting was still in Simon's possession; however, a reversal of fortune suffered in the wake of World War I forced him to sell some of his pictures, among them, his beloved Vermeer. As recorded in the household log for his New York mansion, Frick was soon informed of the picture's availability. On February 27, 1919, he noted:

> Mr. De Wild called & told me the pictures of Mr. Simon of Berlin were for sale, that his brother (De Wild's) had cabled him . . . I told him to cable asking if a certain picture by Vermeer was for sale— 30 x 36. A day or two ago Joseph Duveen called & told me he was informed that Simon was willing to sell this Vermeer & he was negotiating for it.[83]

It was Carel F.L. de Wild (1870–1922) who alerted Frick to the availability of that "certain picture by Vermeer"—the coveted *Mistress and Maid*. Carel, like his brother Derix (1869–1932), was a paintings restorer whom Frick consulted periodically for restoration and picture advice.[84] Because of their close involvement with collectors, dealers, and museums, the De Wilds were often privy to the changing fortunes of collectors and subsequent availability of works. The art dealer Joseph Duveen (1869–1939), also mentioned in the diary's account, was well known to Frick, who had purchased from the Duveen firm many of his prized bronzes, porcelains,

furniture, and, perhaps most famously, *The Progress of Love*, a series of eighteenth-century paintings by Jean-Honoré Fragonard (1732–1806).

The next mention of *Mistress and Maid* occurs on March 28, when Frick writes a peculiar entry in his household journal:

> Regarding the Vermeer referred to under date of Feb. 27th:
> I have told Mr. de Wild to cable his brother to withdraw & say he could find no one interested in the pictures. I have also told Mr. de Wild if I bought the Vermeer thro' Duveens, I would pay him $5000.00. I do this after having talked with Mr. Joseph Duveen this morning.[85]

The following installment, dated March 31, discloses the unusually large number of participants involved in the potential sale:

> Joseph Duveen showed me a telegram from A. Peyer [sic] to Scott & Fowles offering the Vermeer of Delft at 650 florins. Scott saying they would charge no profit. Told him he might bring the picture over & I would then decide whether I would purchase.[86]

Abraham Preyer (1862–1927) was a dealer based in The Hague. Scott & Fowles, dealers headquartered in New York, had been involved in sales to Frick in the past. Preyer, lacking direct access to the wealthy American clientele served by Duveen Brothers and Scott & Fowles, occasionally acted on behalf of the firms to procure art and was subsequently compensated for his assistance.[87]

This complicated transaction was made even more so by world events. Although an armistice with Germany had been declared in November 1918, peace terms had yet to be signed; thus the Allies and Central Powers remained officially locked in conflict. Scott & Fowles were therefore required, in accordance with the Trading with the Enemy Act, to obtain a license to enter into contract with Abraham Preyer to buy two paintings—the Vermeer and another by the Dutch master Frans Hals (1582/83–1666)—from Simon's collection. While Preyer was a native of the Netherlands, a neutral country in the conflict, he acted as agent for Simon, a German resident, thus necessitating the license.[88]

Scott & Fowles entered into agreement with Preyer to secure the Vermeer, while Duveen liaised with Frick. Duveen informed Frick that the work would cost a total of $289,300. The Vermeer would remain in Preyer's vault in the Netherlands until the signing of the peace treaty, at which time Duveen would dispatch an employee from their Paris gallery to collect it.[89] The sale could not have happened without the Duveen Brothers and Scott & Fowles, although the former informed Frick, "We have no pecuniary interest in the transaction whatsoever, and we are only concerned in assisting you to the purchase of this great picture."[90] Duveen's had similarly forfeited a profit in the sales to Frick of *The Mall in St. James's Park* by Thomas Gainsborough (1727–1788) in 1914 and *The Progress of Love* panels by Fragonard in 1915, probably with the hope of achieving future lucrative deals. Despite Duveen's emphatic disclaimer, Frick, ever cautious, rejoined: "I take no chances on this being the genuine Vermeer, in good condition. I hold you responsible for these matters."[91] Frick directed the deposit of $300,000 in Liberty Loan Bonds to the Guaranty Trust Company in payment for the canvas, "after the conclusion of peace with Germany, or when it can be legally done."[92]

On the final day of May 1919, the Guaranty Trust Company wrote to Frick to acknowledge payment and released the painting.[93] The shrewd industrialist tallied the total cost of his new painting in a handwritten calculation that included the base price, commissions, interest, and even the cost of the many cables sent to and fro. By his own accounting, Frick paid $299,989.50 for Vermeer's *Mistress and Maid*.[94] It was not his most expensive purchase—that distinction belonged to Velázquez's *King Philip IV of Spain* for which he paid $475,000—but it was surely one of his most challenging.

A Fitting Swan Song

Today *Mistress and Maid* is displayed in the Frick's West Gallery, just as it was when Frick lived in the mansion. One can imagine him in this vast space where "often late at night, at the end of a trying day, when perfect stillness reigned, he would slip noiselessly, almost furtively, into the darkened gallery, turn on the lights and sit for an hour or more" to contemplate his collection.[95] The canvas—identified in Frick's records as "Lady with a Letter" or "Reading a Letter"—arrived in New York on August 13, 1919, and was immediately escorted to his palatial summer home Eagle Rock, in Pride's Crossing, Massachusetts, where it was installed in the dining room.[96] So

captivated was Frick by his new purchase that he changed his customary seat at the table for one that offered a better view of Vermeer's scene.[97] That autumn, the painting arrived at the Manhattan mansion.[98] Showing his latest acquisition to an unidentified friend, the proud owner declared, "I can only hope that the public will get one-half the pleasure that has been afforded me in the enjoyment of these masterpieces in proper surroundings. I want this collection to be my monument."[99]

As only thirty-five or thirty-six extant works are securely attributed to Vermeer today—from an output estimated to have included between forty-four and sixty pictures—Frick's acquisition of three paintings by the Dutch master was a supreme achievement.[100] While the taciturn collector was reserved when it came to sharing his thoughts on his art holdings, he referred to *Mistress and Maid* as "one of the finest pictures" in his possession.[101] It was also the last painting that Frick would acquire before his death on December 2, less than four months after Vermeer's masterpiece had joined his collection.

Notes

1 Application For License To Take Part In A Financial Transaction Involving "Trading With The Enemy," undated. Art Collecting Files of Henry Clay Frick. The Frick Collection/Frick Art Reference Library Archives.

2 This painting is *Still Life with Fruit* painted by Jan van Os in 1769 (today in the collection of The Frick Pittsburgh).

3 Artists Carel Fabritius (1622–1654) and Leonaert Bramer (1596–1674) have been proposed as possible mentors, as have Abraham Bloemaert (1566–1651) and his son Hendrick Bloemaert (ca. 1601–1672), distant relatives of Vermeer's. For an excellent discussion of these proposals and their relative merits, see Franits 2015, 14–17.

4 Montias 1989, 206.

5 Montias 1989, 212.

6 Some of the dates proposed for the picture are 1666–67 (A. Blankert in Blankert, Montias, and Aillaud 2007); ca. 1667–68 (Wheelock 1995); ca. 1666–67 (Liedtke 2008); ca. 1667–68 (Franits 2015); and ca. 1666–67 (Schütz 2015). Jørgen Wadum, who thinks the painting is from an earlier period in Vermeer's career, dates it to about 1659–60; Wadum 1998, 213.

7 Schama 1987, 318.

8 Carlson 1994, 87–89, 94.

9 Schama 1987, 455.

10 For a seminal study on this topic, see Franits 1993.

11 For more on this subject, see Marieke de Winkel, "Ambition and Apparel," in Boston 2015, 55–73.

12 Nevitt 2001, 105.

13 See, for example, Simon Schama's discussion of maids as undesirables in seventeenth-century society and of the satire *The Seven Devils Ruling Present-Day Maidservants* of the 1680s; Schama 1987, 455–58.

14 For a detailed discussion on these ordinances, see Carlson 2006.

15 Schama 1987, 459.

16 Rybczynski 1986, 72.

17 Carlson 1994, 89.

18 Montias 1989, 160–61.

19 De Winkel, "Ambition and Apparel," in Boston 2015, 55–73.

20 Additional sumptuary laws restricting maid attire were also passed in 1682 and 1734; Pol 2011, 177.

21 Carlson 2006, 230.

22 Liedtke 2009, 23n.1, following the suggestion of costume historian Marieke de Winkel.

23 As observed in Wheelock 1995, 147.

24 For the mistress's attire, see Ribeiro 2017, 125.

25 Jongh 1975–76.

26 For more on this drawing, see Monique Rakhorst's entry (cat. 44) in Salem and Amsterdam 2015, 172–73.

27 For a discussion of the pearl as glass, see A. Bailey 2001, 124. As reported in Janssen 2014, Vincent Icke proposes that the large pearls in Vermeer's paintings may be silver or polished tin.

28 This is described as "a yellow satin mantle with white fur trimmings"; see Montias 1989, 339.

29 Montias 1989, 196 (possibility of Catharina Bolnes as model) and 237 (notes her "unusual elegant hand" in signing documents).

30 True ermine derives from the stoat, an animal whose brown coat turns white in winter except for the black tip of its tail; the spots that appear on the fur are actually the tail tips of many stoats; Winkel 1998, 329.

31 As pigment analyses were still in progress at the time of this essay's publication, it was not possible to identify the composition of the pigment mixtures precisely. Metropolitan Museum of Art Conservator Dorothy Mahon, Research Scientist Silvia A. Centeno, and I are preparing a detailed discussion of these studies for a future publication.

32 For Vermeer's estate inventory listing these objects, see Montias 1989, 191 and 342.

33 Greenwich and Dublin 2003, 26–27.

34 Greenwich and Dublin 2003, 19.

35 Montias 1989, 308, doc. 251.

36 Liedtke 2008, 127.

37 Alan Chong has identified this casket as the product of Indian artisans, who intended it for Portuguese consumers and shipped it to Europe from Goa. For more on this, see Chong 2013. My thanks to Christina An, doctoral candidate at Boston University, for alerting me to this reference.

38 See, for example, Nevitt 2001, 104.

39 Schwartz 2017, 34.

40 Metsu scholar Adriaan Waiboer notes that although the picture is heavily overpainted, the maid figure was likely part of Metsu's original composition. Email exchange of December 1, 2017. I am grateful to Dr. Waiboer for sharing his thoughts on the painting with me.

41 I thank Eric Gordon, Head of Painting Conservation, The Walters Art Museum, for sharing this information with me. Email correspondence of October 26, 2017.

42 Wheelock 1995, 159.

43 Jowell 1998, 49.

44 The size of *Mistress and Maid* (90.2 × 78.7 cm; 35 ½ × 31 in.) is comparable to *The Art of Painting* (120 × 100 cm; 47 ¼ × 39 ⅜ in.), dated about 1662–68, and *Allegory of Faith* (114.3 × 88.9 cm; 45 × 35 in.), dated about 1670–74.

45 Wheelock 1995, 147.

46 Liedtke 2000, 242.

47 For the original Dutch and a discussion of De Grebber's rules, see Thiel 1965, 126.

48 This opinion has been expressed recently by Albert Blankert in Blankert, Montias, and Aillaud 2007, 148.

49 I am extremely thankful to Dorothy Mahon for her discussions with me on this (as per email communications of February 18, 2018) and equally to Arthur Wheelock for his insightful analysis of the painting in Wheelock 1995.

50 Wheelock 1995, 141–47. For their concurrence with Wheelock's opinion, see Liedtke 2008, 129, and Schwartz 2017, 116.

51 Wheelock drew this conclusion about the dark priming layer from the information published in Kühn 1968.

52 This clarification, made by Dorothy Mahon, is based on her observations following a careful study of the painting when the surface was examined with the stereomicroscope and in the IRR image. However, since scientific examinations of the canvas were ongoing at the time of this publication, final conclusions may differ.

53 It should be remembered that the backdrop of *Girl with a Pearl Earring* was originally a glossy dark green; its current black appearance is the result of chemical changes in the pigments over time. For more on this, see Groen, Van der Werf, Van den Berg, and Boon 1998, 169–78.

54 Suhr did question the curtain's state of finish, which is not as well defined as other areas of the composition. For more on this, see Suhr 1952–53.

55 These technical studies included XRF analysis (X-ray fluorescence), IRR (infrared reflectography), and examination with the stereomicroscope. Additionally, a new X-radiograph was made of the painting and minute paint samples were removed from the background perimeter. These were taken from locations that had not been examined in the Kühn investigation.

56 As stated in note 31, the precise pigment mixtures are still to be determined.

57 While it might be presumed that the color change is due to changes in the yellow lake, scientific investigations of the pigment were still ongoing at the time of this essay. The pigment mixture will be identified further in a future publication by Mahon and Centeno.

58 The use of ultramarine in *Mistress and Maid* and other paintings by Vermeer was cited previously in an examination report made by the Doerner Institute, November 16, 1965. This report is contained in The Frick Collection/Frick Art Reference Library Archives. See also Kühn 1968.

59 For the pigments used in high-life genre paintings and a detailed analysis of the use of ultramarine in these paintings, see E. Melanie Gifford and L. Deming Glinsman in Paris, Dublin, and Washington 2017, 65–83.

60 On January 12, 2018, the following met in the Paintings Conservation Studio at the Metropolitan Museum of Art to discuss the IRR and various other technical materials concerning Vermeer's *Mistress and Maid*: Maryan W. Ainsworth, Silvia A. Centeno, Margaret Iacono, Dorothy Mahon, Esmée Quodbach, Xavier F. Salomon, and Arthur K. Wheelock, Jr. During this session, Wheelock expressed his belief, an opinion shared by several of the other participants, that the design represented a tapestry.

61 For a detailed discussion of the numerous alterations made by Vermeer to this picture, see Ainsworth 1982, 18–26, and Liedtke 2008, 66–69.

62 I wish to thank Elizabeth Cleland for making this suggestion and for identifying the comparative tapestry example. Both Cleland and Wheelock believe a Flemish tapestry would be a likely source due to characteristics such as the fullness of the figures and the seeming presence of garlands or swags in the design.

63 Due to space limitations, this essay discusses only some of the more notable owners of Vermeer's *Mistress and Maid*. Although a complete provenance for the painting is still wanting, Liedtke (2008, 196) provides a detailed listing; however, he incorrectly includes Knoedler, New York, as Frick's source for the work. Esmée Quodbach is at work on a comprehensive provenance for the painting.

64 Liedtke 2008, 129; B. Broos in Washington and The Hague 1995, 184–85.

65 For more on Van Ruijven and his collection, see Montias 1989, 246–62.

66 Schwartz 2017, 10.

67 No extant records survive to confirm this benefactor relationship. Montias infers this, wisely I think, based on the archival findings discussed in this text and by taking into account the 1696 auction records of the collection of Jacob Abrahamsz. Dissius (d. 1695), husband of Magdalena van Ruijven (1655–1682) and son-in-law of Van Ruijven and De Knuijt. For a full account, see Montias 1989, 248–58; for a list of the paintings by Vermeer in the so-called Dissius Auction (May 16, 1696, sale of 124 paintings in Amsterdam by the merchant Gerard Hoet II), see Montias 1989, 363–64, doc. 439.

68 Hoet 1752–70, 1: 34, lot 7.

69 For more on this, see Montias 1987, 68–76.

70 Wheelock via email, March 11, 2018.

71 For more on this anonymous auction, *Notitie van een extra fray cabinet schilderyen … ,* held on October 15–16, 1738, see Grijzenhout 2010.

72 For a concise historical appraisal of Vermeer's oeuvre, see Franits 2015, 294–302.

73 Jowell 1998.

74 As M.J. Ripps states, the painting came into the possession of Thos. Lawrie & Co. at some point before 1905, following its ownership by Paulovstof. When the Lawrie firm was dissolved, Arthur Joseph Sulley, previously a principal of Lawrie's, retained ownership of the painting. Ripps also notes that M. Knoedler & Co. held a half-share in *Mistress and Maid* with Sulley's. See Ripps 2014, 168.

75 *Sheffield Daily Telegraph* 1905.

76 *Illustrated Sporting and Dramatic News* 1905.

77 *New York Times* 1919.

78 In order to sort out the painting's acquisition by Frick, I have examined letters, telegrams, and invoices between various agents, art dealers, and Henry Clay Frick. These are preserved in various archives including The Frick Collection/Frick Art Reference Library Archives and the Duveen Brothers Records and M. Knoedler & Co. Records, both kept at the Getty Research Institute, Los Angeles.

79 Davidson 1968, 298.

80 Schütz 2015, 233, no. 24. Liedtke 2008, 196, no. 21.

81 Ripps 2014, 170. Although Ripps states that Duveen's was not involved in the transaction, new archival evidence shows that while Duveen's did not receive financial compensation, their role in the deal was crucial. Colin B. Bailey, former Peter Jay Sharp Chief Curator of The Frick Collection, first identified Duveen Brothers' involvement in the sale and noted this in a text panel accompanying an installation of The Frick Collection's three paintings by Vermeer in 2001.

82 Letter from Arthur J. Sulley to Henry Clay Frick dated May 4, 1914. Art Collecting Files of Henry Clay Frick. The Frick Collection/Frick Art Reference Library Archives.

83 See February 27, 1919, entry in One East 70th Street Papers, Series: Daily Life. The Frick Collection/Frick Art Reference Library Archives. The entry was written on behalf of Frick in the hand of his secretary Alice Braddel.

84 Frick sought De Wild's opinion, for example, regarding his painting *Old Woman with a Book*, then attributed to Rembrandt and now assigned to Carel van der Pluym (1625–1672). See the entry by Iacono on this painting in New York 2011, 64–72. Additional examples of De Wild's service to Frick as an art advisor are contained in the Archief Carel F.L. de Wild Sr. (0227), housed in the Rijksbureau voor Kunsthistorische Documentatie/Netherlands Institute for Art History (RKD). I am grateful to Michiel Franken and Ramses van Bragt, both of the RKD, for their kind assistance in helping me access this material.

85 March 27, 1919, entry in One East 70th Street Papers, Series: Daily Life. The Frick Collection/Frick Art Reference Library Archives.

86 March 31, 1919, entry in One East 70th Street Papers, Series: Daily Life. The Frick Collection/Frick Art Reference Library Archives. In a letter from Joseph Duveen to Frick dated April 17, 1919, Duveen tells Frick that 650,000 gulden, the price for the picture, was equivalent to $263,000, exclusive of a ten percent commission due to Abraham Preyer. Art Collecting Files of Henry Clay Frick. The Frick Collection/Frick Art Reference Library Archives.

87 In a letter dated January 24, 1925, Preyer reveals his role to Joseph Duveen. "I have mentioned to the Passport Bureau at Washington that I represent you and Scott & Fowles in Europe in such a way that any great works of art which come here in the market will be negotiated with by [sic] me and in case they are in your line, offered to you at once." Duveen Brothers Records, 1876–1981. Series II.E. Correspondence: Pr-Pz. The Getty Research Institute, Los Angeles.

88 See License issued under Section 5 (a) of the Trading with the Enemy Act dated March 25, 1919. Duveen Brothers Records, 1876–1981. Collectors' files: Henry

Clay Frick, 2. The Getty Research Institute, Los Angeles. The other painting, Frans Hals's *Portrait of a Seated Woman,* was later purchased by Andrew Mellon from Duveen Brothers in 1920 and is part of the collection of the National Gallery of Art, Washington, D.C.

89 This price included Preyer's ten percent commission. For more on this, see Joseph Duveen to Frick of April 17, 1919. Art Collecting Files of Henry Clay Frick. The Frick Collection/Frick Art Reference Library Archives.

90 Joseph Duveen to Frick, April 22, 1919. Art Collecting Files of Henry Clay Frick. The Frick Collection/Frick Art Reference Library Archives.

91 Frick to Duveen, April 28, 1919. Art Collecting Files of Henry Clay Frick. The Frick Collection/Frick Art Reference Library Archives.

92 Frick to Mr. A.J. Hemphill, Chairman, Guarantee Trust Company, April 28, 1919. Art Collecting Files of Henry Clay Frick. The Frick Collection/Frick Art Reference Library Archives.

93 The painting was released to Walter Dowdeswell, an art dealer acting as agent for Duveen Brothers. See letter from W.G. Avery, Guaranty Trust Company of New York to Frick, May 31, 1919. Art Collecting Files of Henry Clay Frick. The Frick Collection/Frick Art Reference Library Archives.

94 "Relative to Purchase of Picture By Vermeer," Art Collecting Files of Henry Clay Frick. The Frick Collection/Frick Art Reference Library. Among these costs is a $5,000 payment to Carel de Wild. De Wild described this as a "commission" in his personal records.

See entry of September 18, 1919, contained in Carel de Wild ledger dated October 1916–February 1921. Archief Carel F.L. de Wild Sr. (0227), housed in the Rijksbureau voor Kunsthistorische Documentatie/ Netherlands Institute for Art History (RKD).

95 Harvey 1928, 335.

96 This was recorded in the 1919 household diary for One East 70th Street. "Aug. 13—The Vermeer arrived and Tom Kerr of Duveen's goes to Prides with it tomorrow 10:00 AM." One East 70th Street Papers, Series: Daily Life. The Frick Collection/Frick Art Reference Library Archives.

97 As cited in Helen Clay Frick's notebook of recollections about her father, ca. 1920s. Helen Clay Frick Papers, Series: Alphabetical File. The Frick Collection/Frick Art Reference Library Archives.

98 "Sept. 7—Brought the Vermeer from Pride's." One East 70th Street Papers, Series: Daily Life. The Frick Collection/Frick Art Reference Library Archives.

99 Harvey 1928, 336.

100 According to current scholarship, thirty-four pictures are generally agreed to have been executed by Vermeer, with another three debated by some. Wayne Franits publishes this current estimation of Vermeer's oeuvre, following previous ones made by John Michael Montias. Franits 2015, 123; Montias 1989, 265–67.

101 As noted by Frick's daughter, Helen Clay Frick, in an entry for August 20, 1919, contained in the 1919 household diary for One East 70th Street. One East 70th Street Papers, Series: Daily Life. The Frick Collection/Frick Art Reference Library Archives.

BIBLIOGRAPHY

ARCHIVAL SOURCES

Archief Carel F.L. de Wild Sr. Rijksbureau voor Kunsthistorische Documentatie/Netherlands Institute for Art History (RKD), The Hague

Duveen Brothers Records, 1876–1981. The Getty Research Institute, Los Angeles

The Frick Collection/Frick Art Reference Library Archives, New York

Knoedler Archive, M. Knoedler & Co. Records, ca. 1848–1971. The Getty Research Institute, Los Angeles

PUBLICATIONS

Ainsworth 1982 Ainsworth, Maryan W. *Art and Autoradiography: Insights into the Genesis of Paintings by Rembrandt, Van Dyck, and Vermeer.* New York, 1982.

A. Bailey 2001 Bailey, Anthony. *Vermeer: A View of Delft.* New York, 2001.

C. Bailey 2001 Bailey, Colin B. "Highlights from the Permanent Collection: Vermeer's *Mistress and Maid.*" *The Frick Collection Members' Magazine* (2001): 11.

Blankert, Montias, and Aillaud 2007 Blankert, Albert, John Michael Montias, and Gilles Aillaud. *Vermeer.* New York, 2007.

Boston 2015 Ronnie Baer et al. *Class Distinctions: Dutch Paintings in the Age of Rembrandt and Vermeer.* Exh. cat. Boston (Museum of Fine Arts), 2015.

Boston 2008 Pedro Moura Carvalho. *Luxury for Export: Artistic Exchange Between India and Portugal Around 1600.* Exh. cat. Boston (Isabella Stewart Gardner Museum), 2008.

Carlson 2006 Carlson, Marybeth. "'There is No Service Here But My Service!': Municipal Attempts to Regulate Domestic Servant Behavior in Early Modern Holland." In *Power and the City in the Netherlandic World*, edited by Wayne te Brake and Wim Klooster, 225–34. Leiden and Boston, 2006.

Carlson 1994 Carlson, Marybeth. "A Trojan Horse of Worldliness? Maidservants in the Burgher Household in Rotterdam at the End of the Seventeenth Century." In *Women of the Golden Age: An International Debate on Women in Seventeenth-Century Holland, England and Italy*, edited by Els Kloek, Nicole Teeuwen, and Marijke Huisman, 87–101. Hilversum, 1994.

Chong 2013 Chong, Alan. "Sri Lankan Ivories for the Dutch and Portuguese." *Journal of Historians of Netherlandish Art* 5, no. 2 (Summer 2013). DOI: 10.5092/jhna.2013.5.2.16.

Davidson et al. 1968 Davidson, Bernice, et al. *The Frick Collection: An Illustrated Catalogue. Volume I. Paintings. American, British, Dutch, Flemish and German.* New York, 1968.

Franits 2015 Franits, Wayne E. *Vermeer.* London, 2015.

Franits 1993 Franits, Wayne E. *Paragons of Virtue: Women and Domesticity in Seventeenth-Century Dutch Art.* Cambridge, New York and Melbourne, 1993.

Greenwich and Dublin 2003 Peter C. Sutton, Lisa Vergara, and Ann Jensen Adams with Jennifer Kilian and Marjorie E. Wieseman. *Love Letters: Dutch Genre Paintings in the Age of Vermeer.* Exh. cat. Greenwich, CT (Bruce Museum of Arts and Science) and Dublin (National Gallery of Ireland), 2003.

Grijzenhout 2010 Grijzenhout, Frans. "Een schrijfstertje van Vermeer. Jacob Oortman en de Dissius-veiling van 1696." *Oud Holland* 123, no. 1 (2010): 65–75.

Groen, Van der Werf, Van den Berg, and Boon 1998 Groen, Karin M., Inez D. van der Werf, Klaas Jan van den Berg, and Jaap J. Boon. "Scientific Examination of Vermeer's *Girl with a Pearl Earring.*" In *Vermeer Studies*, edited by Ivan Gaskell and Michiel Jonker, 169–78. New Haven and London, 1998.

Harvey 1928 Harvey, George. *Henry Clay Frick: The Man.* New York, 1928.

Hoet 1752–70 Hoet, Gerard. *Catalogus of naamlyst van schilderyen, met derzelve pryzen …* 3 vols. The Hague, 1752–70.

***Illustrated Sporting and Dramatic News* 1905** "There is a second picture in Bond-street …" *Illustrated Sporting and Dramatic News,* December 16, 1905, 640.

Janssen 2014 Janssen, Joris. "Curious Discovery: Girl with the Pearl Has No Pearl." *New Scientist* (November 28, 2014). https://newscientist.nl/nieuws/curieuze-ontdekking-meisje-met-de-parel-heeft-geen-parel/

Jongh 1975–76 Jongh, Eddy de. "Pearls of Virtue and Pearls of Vice." *Simiolus: Netherlands Quarterly for the History of Art* 8, no. 2 (1975–76): 69–97.

Jowell 1998 Jowell, Frances Suzman. "Vermeer and Thoré-Bürger: Recoveries of Reputation." In *Vermeer Studies*, edited by Ivan Gaskell and Michiel Jonker, 35–57. New Haven and London, 1998.

Krul 1644 Krul, Jan Harmensz. *Pampiere Wereld.* Amsterdam, 1644.

Kühn 1968 Kühn, Hermann. "A Study of the Pigments and the Grounds Used by Jan Vermeer." *Report and Studies in the History of Art* 2 (1968): 154–75.

Liedtke 2009 Liedtke, Walter A. *The Milkmaid by Johannes Vermeer.* New York, 2009.

Liedtke 2008 Liedtke, Walter A. *Vermeer: The Complete Paintings.* Ghent and New York, 2008.

Liedtke 2000 Liedtke, Walter A. *A View of Delft: Vermeer and His Contemporaries.* Zwolle, 2000.

Montias 1989 Montias, John Michael. *Vermeer and His Milieu: A Web of Social History.* Princeton, 1989.

Montias 1987 Montias, John Michael. "Vermeer's Clients and Patrons." *The Art Bulletin* 69, no. 1 (March 1987): 242–62.

Nevitt 2001 Nevitt, H. Rodney, Jr. "Vermeer on the Question of Love." In *The Cambridge Companion to Vermeer*, edited by Wayne E. Franits, 89–110. Cambridge, UK, and New York, 2001.

New York 2011 Colin B. Bailey et al. *Rembrandt and His School: Masterworks from the Frick and Lugt Collections.* Exh. cat. New York (The Frick Collection), 2011.

New York Times 1919 "Another Vermeer Bought By Frick." *The New York Times*, September 14, 1919, 18.

Paris, Dublin, and Washington 2017 Adriaan E. Waiboer et al. *Vermeer and the Masters of Genre Painting: Inspiration and Rivalry*. Exh. cat. Paris (Musée du Louvre), Dublin (National Gallery of Ireland) and Washington (National Gallery of Art), 2017.

Pol 2011 Pol, Lotte van de. *The Burgher and the Whore*. Translated by Liz Waters. New York, 2011.

Ribeiro 2017 Ribeiro, Aileen. *Clothing Art: The Visual Culture of Fashion, 1600–1914*. New Haven, 2017.

Ripps 2014 Ripps, M.J. "The London Picture Trade and Knoedler & Co.: Supplying Dutch Old Masters to America, 1900–1914." In *British Models of Art Collecting and the American Response: Reflections Across the Pond*, edited by Inge Reist, 163–80. Farnham, UK, 2014.

Rybczynski 1986 Rybczynski, Witold. *Home: A Short History of an Idea*. New York, 1986.

Salem and Amsterdam 2015 Katrina H. Corrigan, Jan van Campen, and Femke Diercks, with Janet C. Blyberg, eds. *Asia in Amsterdam: The Culture of Luxury in the Golden Age*. Exh. cat. Salem, MA (Peabody Essex Museum) and Amsterdam (Rijksmuseum), 2015.

Schama 1987 Schama, Simon. *The Embarrassment of Riches: An Interpretation of Dutch Culture in the Golden Age*. New York, 1987.

Schütz 2015 Schütz, Karl. *Vermeer: The Complete Works*. Cologne, 2015.

Schwartz 2017 Schwartz, Gary. *Vermeer in Detail*. Antwerp, 2017.

Sheffield Daily Telegraph 1905 "London Correspondence." *Sheffield Daily Telegraph*, November 7, 1905, 7.

Suhr 1952–53 Suhr, William. "Record of Treatment by Mr. William Suhr, December 1952–September 1953; Vermeer—Mistress and Maid," no. 126. The Frick Collection/Frick Art Reference Library Archives.

Thiel 1965 Thiel, P.J.J van. "De Grebbers regels van de Kunst." *Oud-Holland* 80, no. 2 (1965): 126–31.

Wadum 1998 Wadum, Jørgen. "Contours of Vermeer." In *Vermeer Studies*, edited by Ivan Gaskell and Michiel Jonker, 201–23. New Haven and London, 1998.

Washington and The Hague 1995 Arthur K. Wheelock, Jr. *Johannes Vermeer*. Exh. cat. Washington (National Gallery of Art) and The Hague (Mauritshuis). New Haven and London, 1995.

Wheelock 1997 Wheelock, Arthur K., Jr. *Vermeer: The Complete Works*. New York, 1997.

Wheelock 1995 Wheelock, Arthur K., Jr. *Vermeer & the Art of Painting*. New Haven, 1995.

Winkel 1998 Winkel, Marieke de. "The Interpretation of Dress in Vermeer's Paintings." In *Vermeer Studies*, edited by Ivan Gaskell and Michiel Jonker, 327–39. New Haven and London, 1998.

PHOTOGRAPHY CREDITS

Photographs in this book have been provided by the owners or custodians of the works. The following list applies to those photographs for which a separate credit is due.

figs. 1, 2, 3; pp. 2, 58, 62 photo Michael Bodycomb

p. 8 © RMN-Grand Palais / Art Resource, NY

p. 14 photo Michael Agee

fig. 4 © The Metropolitan Museum of Art / Art Resource, NY

fig. 5 © Gemäldegalerie Alte Meister, Staatliche Kunstsammlungen Dresden; photo Herbert Boswank

fig. 6 © National Gallery, London / Art Resource, NY

fig. 8 photo Studio Tromp, Rotterdam

figs. 11, 12, 17 © National Gallery of Ireland

figs. 15, 20, 21 © National Gallery of Art / Art Resource, NY

fig. 19 photo Evan Read

fig. 22 © Art Institute of Chicago / Art Resource, NY

fig. 23 photo George Koelle